# MEDIEVAL
# CHURCH WINDOW TRACERY
# IN ENGLAND

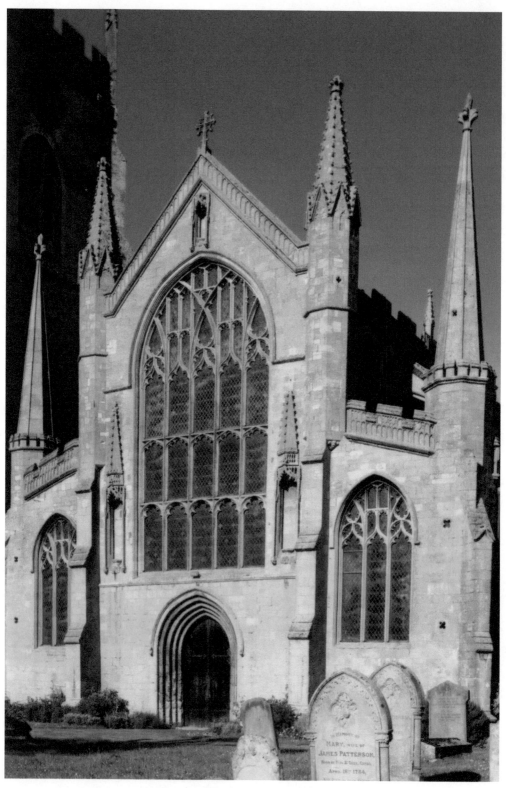

*Three-light subarcuations of the Perpendicular five-light nave west window echo the design of the three-light aisle windows. Terrington St Clement.*

# MEDIEVAL
# CHURCH WINDOW TRACERY
# IN ENGLAND

## Stephen Hart
with photographs by the author

THE BOYDELL PRESS

First published 2010
The Boydell Press, Woodbridge
Reprinted in paperback 2012

ISBN 978 1 84383 533 2 hardback
ISBN 978 1 84383 760 2 paperback

The Boydell Press is an imprint of Boydell & Brewer Ltd
PO Box 9, Woodbridge, Suffolk IP12 3DF, UK
and of Boydell & Brewer Inc.
668 Mt Hope Avenue, Rochester, NY 14620, USA
website: www.boydellandbrewer.com

A CIP catalogue record for this book is available from the British Library

The publisher has no responsibility for the continued existence or accuracy of URLs for external or third-party internet websites referred to in this book, and does not guarantee that any content on such websites is, or will remain, accurate or appropriate

Printed and bound in Great Britain by TJ Books Limited, Padstow, Cornwall

# Contents

List of Colour Plates      vii
List of Illustrations      viii
Introduction      xiii

CHAPTER 1   Architectural Styles and Window Arch Forms   1
      GOTHIC WINDOW ARCHES   6

CHAPTER 2   Skeletal Frameworks of Window Tracery   11

CHAPTER 3   Origins and Techniques of Tracery   18
      PROTO-TRACERY   18
      PLATE TRACERY   21
      SUNK-SPANDREL TRACERY   21
      BAR TRACERY   22
      STRAP TRACERY   26
      COLONNETTE AND SCULPTURED TRACERY   26
      DROP TRACERY   29
      THE HIERARCHY OF TRACERY   29
      MULLION PROFILES   30

CHAPTER 4   Lancet Style   32

CHAPTER 5   Geometric Tracery Styles   46
      EARLY GEOMETRIC   46
      LATE GEOMETRIC   49
         *Unencircled Foliated Figures and Trilobes*   50
         *The Vesica*   57
         *Spherical Triangles and Squares*   63
         *Stepped Archlets*   67
         *Kentish Tracery*   68
         *Intersecting and Y-Tracery*   71

CHAPTER 6   Curvilinear Tracery                                      76
            OGEE INTERSECTING TRACERY                                84
            RETICULATED TRACERY                                      87
            FALCHION STYLE                                           91
            PETAL TRACERY                                            97
            LEAFED STEM TRACERY                                     101
            FLAMBOYANT TRACERY                                      104
            ASYMMETRICAL SUBARCUATIONS                              110
            UNCLASSIFIED CURVILINEAR                                111

CHAPTER 7   Perpendicular Styles                                    115
            ALTERNATE TRACERY                                       116
            ALTERNATE SUPERMULLIONED                                120
            THROUGH MULLIONS WITHOUT TRACERY                        122
            SUPERMULLIONED TRACERY                                  124
            GRIDIRON TRACERY                                        127
            SUPERTRANSOMS                                           127
            TRACERY WITH PRE-PERPENDICULAR MOTIFS                   128
            ANGULAR TRACERY                                         132
            PANELLED TRACERY                                        132
            LATER PERPENDICULAR                                     134

Glossary                                                            138
Further Reading                                                     142
County Directory of Places Referred to                             143
General Index                                                       148

# List of Colour Plates

Frontispiece    Terrington St Clement, west front

Between pages 114 and 115:

I          Little Walsingham Priory, window of ruined refectory
II         Howden, west front
III        Northborough, south transept
IV         Chartham, chancel east window
V          Grantham, west front of tower
VI         Melton Mowbray, west end of nave
VII        Chipping Norton, east window of south aisle
VIII       Claypole, nave, south aisle and south transept
IX         Ashby Folville, south aisle
X          Swaton, west front
XI         Lawford, south side of chancel
XII        Snettisham, nave west window
XIII       Elsing, chancel east window
XIV        Cotterstock, chancel east window
XV         Higham Ferrers, Archbishop Chichele's School
XVI        Walberswick, south side of nave
XVII       Wortham, south clerestory
XVIII      Southwold, west front of tower
XIX        Barsham, chancel east wall

# List of Illustrations

1a    Northborough, chancel north wall

1b    Brandiston, nave south wall

Fig.1   Gothic window arches

2a    Barnack, Saxon window

2b    Horbling, Norman window

2c    Polebrook, Transitional lancet

3a    Burnham Overy

3b    Harlestone

3c    Bassingbourne

3d    Crick

Fig.2   Coincident and Non-Coincident window-light formats

4a    Cowbit

4b    Caythorpe

4c    Grantham

4d    Great Hale

5a    Sleaford

5b    Sleaford

5c    Heckington

5d    Ringstead

6a    Stibbington

6b    Barton on Humber, St Mary

6c    Clipsham

6d    Tansor

7a    Lynchmere

7b    West Harling

7c    Carlby

7d    Glapthorn

8a    Grasby

8b    Dowsby

8c    Greatford

9a    Etton

9b    Hallaton

9c    Muston

9d    Barrowden

10a   Great Addington

10b   Scotton

10c   Norton Disney

10d   Grafton Underwood

11a   Caythorpe

11b   Swaton

11c   Merton

11d   Barnack

12a   Raunds

12b   Glapthorn

12c   Rockland St Peter

12d   Castle Bytham

13a   Chesterton

13b   Swaton

13c   Great Casterton

14a   Stanion

14b   Stanion

14c   Sudborough

| | | | | |
|---|---|---|---|---|
| 14d | Longthorpe | | 25d | Rickinghall Inferior |
| 15a | Woodnewton | | 26a | Oundle |
| 15b | Little Casterton | | 26b | Orston |
| 15c | Little Casterton | | 26c | Orston |
| 16a | Threekingham | | 26d | Northborough |
| 16b | Ufford | | 27a | Gaddesby |
| 16c | Burton Lazars | | 27b | Spaldwick |
| 16d | Bainton | | 27c | Fishtoft |
| 17a | Polebrook | | 27d | Rippingale |
| 17b | Castle Rising | | 28a | Barton on Humber, St Peter |
| 17c | Tinwell | | 28b | Shifnal |
| 17d | Yaxley | | 28c | Howden |
| 18a | Nassington | | 28d | Barton on Humber, St Mary |
| 18b | Oundle | | 29a | Trowse Newton |
| 18c | Warmington | | 29b | Heydour |
| 18d | Warmington | | 29c | Hedon |
| 19a | Billingborough | | 30a | Coston |
| 19b | Castle Bytham | | 30b | Melton Mowbray |
| 19c | Blundeston | | 30c | Gaddesby |
| 19d | Etton | | 30d | Misterton |
| 20a | Burton Coggles | | 31a | Felsham |
| 20b | Beeston St Lawrence | | 31b | Oundle |
| 20c | Tansor | | 31c | Kislingbury |
| 20d | East Malling | | 31d | Heckington |
| 21a | Caythorpe | | 32a | Aldwinkle, St Peter |
| 21b | Great Hale | | 32b | Blundeston |
| 21c | Great Hale | | 32c | Hingham |
| 22a | Honington | | 32d | Attleborough |
| 22b | Castor | | Fig. 3 | The Geometry of Spherical Triangles |
| 22c | Folkingham | | 33a | Sudborough |
| 22d | West Walton | | 33b | Quarrington |
| 23a | Castle Bytham | | 33c | Great Hale |
| 23b | Barton on Humber, St Mary | | 33d | Morton |
| 23c | Stanion | | 34a | Gosberton |
| 23d | Grantham | | 34b | Bingham |
| 24a | Sheldwich | | 34c | Shifnal |
| 24b | Icklesham | | 34d | Northborough |
| 24c | Bedingham | | 35a | Chartham |
| 24d | Oundle | | 35b | Bobbing |
| 25a | Soham | | 35c | Winchelsea |
| 25b | North Creake | | 35d | Billingborough |
| 25c | Stoke Golding | | | |

| | | | |
|---|---|---|---|
| 36a | Barnack | 47a | Snettisham |
| 36b | Barton on Humber, St Mary | 47b | Ashby Folville |
| 36c | Hemblington | 47c | Folkingham |
| 36d | Billingford | 47d | Glaston |
| 37a | Great Gonerby | 48a | Grantham, south chapel |
| 37b | Stoke Golding | 48b | Heckington |
| 37c | Bulwick | 48c | Holbeach |
| 37d | Merton | 49a | Bozeat |
| 38a | Quidenham | 49b | Sutton |
| 38b | Carlton Scroop | 49c | Heydour |
| 38c | Ashwell, Rutland | 49d | Aylmerton |
| 39a | Stanion | 50a | Frisby-on-the-Wreake |
| 39b | Bearstead | 50b | Holbeach |
| 39c | Barnwell | 50c | Attleborough |
| 39d | Winfarthing | 50d | Boughton Aluph |
| 40a | Eleanor Cross, Hardingstone | 51a | Holbeach |
| 40b | Stoke Golding | 51b | South Wooton |
| 40c | Somerby | 51c | Sleaford |
| 41a | Howden | 51d | Boston |
| 41b | Howden | 52a | Frisby-on-the-Wreake |
| 41c | Ulcombe | 52b | Snettisham |
| 41d | Syderstone | 52c | Boothby Pagnell |
| 42a | Claypole | 52d | Ingham |
| 42b | Barnack | 53a | Burton Lazars |
| 42c | Threekingham | 53b | North Leverton |
| 42d | South Creake | 53c | Cromwell |
| 43a | Ufford | 53d | Bolton Abbey |
| 43b | Norton Subcourse | 54a | Salford Priors |
| 43c | Finedon | 54b | Chipping Norton |
| 43d | Clipsham | 54c | Brede |
| 44a | North Elmham | 54d | Oxford |
| 44b | Boothby Pagnell | 55a | Car Colston |
| 44c | Shifnal | 55b | Deeping St James |
| 44d | Great Ryburgh | 55c | Soham |
| 45a | Kibworth | 55d | Kirby Bellars |
| 45b | Somerby | 56a | Billingborough |
| 45c | Sustead | 56b | Ancaster |
| 45d | Gaddesby | 56c | Burton Coggles |
| 46a | Horbling | 56d | Stibbington |
| 46b | Hallaton | 57a | Etchingham |
| 46c | Heckington | 57b | Soham |
| 46d | Raunds | 57c | Kislingbury |

| | | | | |
|---|---|---|---|---|
| 57d | Sutton | 63a | Walpole St Peter |
| 58a | Edington | 63b | St Neots |
| 58b | Colsterworth | 63c | Bungay, St Mary |
| 58c | Necton | 63d | Langham |
| 58d | Yeovil | 64a | Grantham, east end |
| 59a | Glaston | 64b | Carlby |
| 59b | Gaddesby | 64c | Uffington |
| 59c | Boughton Aluph | 65a | Fotheringhay |
| 59d | Beeston St Lawrence | 65b | Swavesey |
| 60a | Sandon | 65c | Lowick |
| 60b | Ashwell, Herts | 65d | Empingham |
| 60c | Harlton | 66a | Whissendine |
| 60d | Coston | 66b | Sporle |
| 61a | Little Casterton | 66c | Aswarby |
| 61b | Earl's Barton | 66d | Fotheringhay |
| 61c | Tinwell | 67a | Earl Stonham |
| 61d | Wakerley | 67b | Harringworth |
| 62a | Badwell Ash | 67c | Stamford, All Saints |
| 62b | Hemblington | 67d | Castor |
| 62c | Hambleton | 68a | Gipping |
| 62d | Gretton | 68b | Lowick |

# Introduction

Books on the architecture of English parish churches, and the glossaries of more general architectural works often do not explore in detail the various window tracery themes that developed within the main medieval architectural styles, usually illustrating only six or seven typical designs from the Norman, Early English, Decorated or Curvilinear and Perpendicular periods. However, within the styles of those periods, many different variations emerged and transitions from one theme to another show that, however superficially different styles may appear, there are usually connections from one to another.

While it is recognised that the window designs of the great cathedrals were influential in the development of tracery patterns, it seems likely that dissemination of design ideas in smaller churches also occurred via other means and, rather than looking to the cathedral precedents, this book aims to show that a continuous thread of development evolved, seemingly independently from major sources. Its purpose is to define the mainstream styles, to differentiate the many sub-styles and variations developed from them, to place those variations within the context of the progression of window tracery design and to demonstrate connections between styles.

Because of the absence of actual dates for instances of their first use, it is difficult to establish a precise chronology for the introduction of particular features or motifs. This is particularly true of the architecturally fertile decades immediately before and after the beginning of the fourteenth century, and in the mature Perpendicular period of the fifteenth century; nevertheless, evidence of continuity can throw light on the progression of development, and in tracing that continuity, a realistic chronology transpires.

In seeking to differentiate tracery styles, a major problem has been to establish an unambiguous basis of classification since analysis has shown that those aspects of a window design that establish its architectural form and

create its visual structure, such as its arch shape and how it is compartmented, are universal to all windows, irrespective of chronological and stylistic boundaries. In the interests of simplification therefore, it was decided that, since a window's visual framework can embrace any tracery style, it should be seen as a separate element of the design, distinct from the tracery style. Tracery style is established by its motifs and patterns rather than by the window's structure, though in certain cases, as for example in Intersecting tracery, the window structure becomes essentially part of the style.

It is hardly necessary to mention that the examples quoted in the text and illustrated are not exclusive instances of their types, and while a few are rarities, most can be found at many churches. The illustrations have been chosen to show the progression of development and it has not been practicable to show every type of composition or variation; readers will no doubt find designs not covered in this book, but with its help, should be able to place any such discovery in relationship to the themes identified.

CHAPTER 1

# Architectural Styles and Window Arch Forms

From the time when the pointed arch first came into general use towards the end of the twelfth century, the development of Gothic architecture in England was a continuous process of transition and development. It continued until the third decade of the sixteenth century, when church building virtually ceased following the Reformation and the Dissolution of the Monasteries by Henry VIII.

Since the early nineteenth century, architectural historians have sought to devise a typology for the various stages of this continuous development and to attribute dates to styles differentiated. Thomas Rickman (1776-1841), in his book *An Attempt to Discriminate the Styles of English Architecture from the Conquest to the Reformation* published in 1817, codified a sequence of four styles – Norman 1066-1198, Early English 1189-1307, Decorated 1307-77 and Perpendicular 1377-1546. Being based partly on the dates of the reigns of monarchs and partly on architectural characteristics, and taking little account of the fact that change from one style to another was gradual and geographically uneven in different parts of the country, the system had its inadequacies. Despite these though, and objections that other important aspects of architectural development, such as in planning, vaulting techniques or pier and arch design of arcades for example, did not coincide with these periods, it gained a wide general acceptance and usage.

Later in the nineteenth century Edmund Sharpe revised Rickman's divisions. Sharpe developed six classifications with different dates as follows: Norman 1066-1145, Transitional 1145-90, Lancet 1190-1245, Geometric 1245-1315, Curvilinear 1315-60 and Rectilinear 1360-1500. As is evident from the names he gives to them, the last four of Sharpe's classifications were based essentially on styles of fenestration. That principle was also

followed by E.A. Freeman in his amply illustrated definitive book *An Essay on the Origin and Development of Window Tracery in England* of 1851, in which he adopts the terms Flowing and Flamboyant in place of Curvilinear, and uses dates that differ from Sharpe. In *Gothic Architecture in England* of 1905 Francis Bond used Sharpe's terms Geometric and Curvilinear, preferring them to alternative proposals such as First Pointed, Middle Pointed and the like advanced by others, and suggested that Geometric phases could be identified as Early and Late, with the latter subdivided into several further groups.

However, the persisting influence of Rickman's system even today is demonstrated by the current use, with some variation of dating, of its main designations for architectural style, i.e. Norman, EE, Dec. and Perp. (to use the common abbreviations) in Nikolaus Pevsner's popular *Buildings of England* series. Periods defined in these books are: Norman eleventh and twelfth century, Transitional 1175- c.1200, Early English 1190-1250, Geometric phase of Decorated 1250-1310, Decorated 1290-1350, and Perpendicular from 1335-50 to 1530. Although these designations do not include Sharpe's Lancet and Curvilinear, or Freeman's Flowing to define architectural periods, those terms occur in descriptions of Early English and Decorated work in the texts. Embodying overlap phases in which features of one period coincide with those of another, the Pevsner chronology forms a practical working basis.

Despite objections that classification and dating systems cut an essentially continuous art into arbitrary sections, in a field of enquiry covering several centuries, some system of chronological terminology is required. This present study will, in general, follow Pevsner's usage as a framework, though incorporating Sharpe's and Freeman's terms and others as applicable. By following the evolution, continuity and overlapping of tracery styles between the periods, any implications that styles ceased at the end of each period, to be suddenly supplanted by a successor, will be avoided. It will be seen that particular styles, and features, could persist for long after their original introduction, continuing in use concurrently with newer developments; the usefulness for dating of a particular feature or style therefore is generally limited to establishing the earliest date at which it was used. There are several instances where contemporary windows of different styles are found in the same wall, for example, in the chancel north wall at Northborough church, Cambs *(Pl. 1a)*. Here three two-light windows have apex tracery of Geometric, Curvilinear and Perpendicular styles although apparently all of one building phase. Another example can be found in the nave of Brandiston church, Norfolk *(Pl. 1b)* where a central three-light Decorated window is flanked by contemporary Perpendicular windows of similar proportions.

Many churches were progressively enlarged, altered or partially rebuilt during the Middle Ages and in the nineteenth century, and later windows

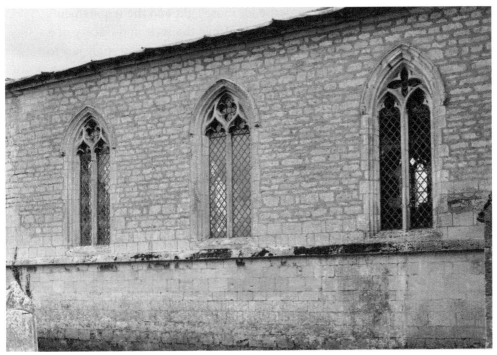

*(a)*

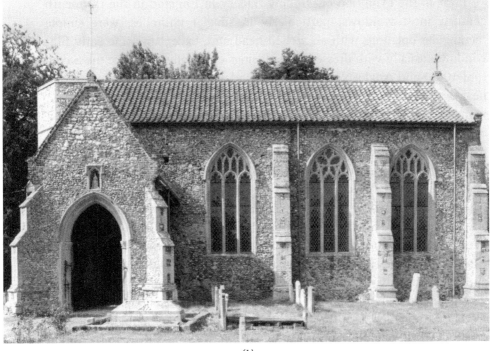

*(b)*

PLATE 1
*a. Northborough. Chancel north wall   b. Brandiston. Nave south wall*

often replaced earlier ones as the desire for more light and the requirements of stained glass demanded larger openings. While the style and tracery of a window can provide an indication of its age, that indication may apply just to the window itself and can only suggest the date of the wall in which it occurs if it was an original part of the structure and not a later insertion or, rarely, an early window reset in a later wall. Careful examination can sometimes reveal clues that a window has been inserted. In ashlar walls, for instance, the levels of the mortar joints between the jamb stones of the window may not coincide with the bed joints of the wall masonry, or in flint walls the quality of the flintwork and its mortar pointing around the window jambs and arch may vary noticeably from that in the rest of the wall.

Following long periods of neglect and deterioration, many medieval churches were comprehensively renovated during the nineteenth century and it may be unknown whether the tracery of their restored windows as seen today reproduces that of the originals, or whether it is entirely the invention of a Victorian architect. It is, however, quite often possible to tell if a window is an original or a renewal by the degree of weathering of its stonework, but it should be borne in mind that the tracery can be restored within the original arch stonework. Clear and sharp arrises of the stone mouldings usually indicate a restored window.

Prior to the evolution of window tracery in England in the thirteenth century, most windows, particularly in smaller churches, were simple rectangular openings with an arched head and, except in some early flint windows, usually with dressed stone facings externally. Those of the Saxon (pre-1066) and Anglo-Norman periods had round arches with the aperture near the outer face of the wall. They were splayed internally and usually set high in the wall to allow maximum admission of light and to discourage illicit entry. Because of the expense of glass, most were probably unglazed, though may have been provided with a translucent fabric screen. The exterior stonework of some early windows has a square rebate around the edge of the opening, thought to be for accommodating the wooden frame of such a screen.

These early windows, even in small churches, were not always simply plain and utilitarian. A Saxon one in the tower at Barnack, Cambs has incised decoration in its stone head *(Pl.2a)*, a Norman chancel window at Horbling, Lincs has colonnettes at its jambs and billet moulding round the arch *(Pl.2b)*, and an unusual two-light Norman window in the ground-floor stage of the flint round tower at Gissing, Norfolk has chevron surface decoration. At Threekingham, Lincs three linked semi-circular label mouldings unite a group of three separate round-headed lancets with moulded jambs, and at Polebrook, Northants a Transitional round-headed lancet has a dogtooth hoodmould with headstops *(Pl.2c)*.

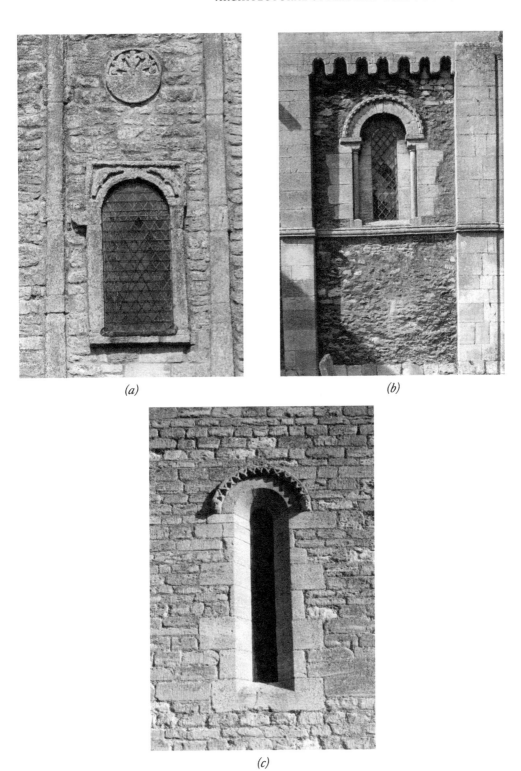

PLATE 2
*a. Saxon window, Barnack  b. Norman window, Horbling  c. Transitional lancet, Polebrook*

## GOTHIC WINDOW ARCHES

Whereas arches of Romanesque style were semi-circular with a radius struck from the central point on its baseline, the curves of the Gothic pointed arch were arcs of a circle struck from two or more centres, meeting at an apex. Typically, pointed window arches were two-centred, based on an equilateral triangle having the radii of the arcs the same length as the base and struck from its ends. However, departures from the equilateral shape also evolved. Acute arches with taller proportions, common in lancets, were achieved by increasing the radii of the arcs and locating their centres outside the baseline. Likewise, lower, obtuse arches were produced by the use of a shorter radius for the arcs, struck from within the baseline.

The four-centred arch was an English innovation of the first quarter of the fourteenth century although initially it was not used in windows. It is a pointed arch in which the arcs at the springings have radii on the springing line, smaller relative to those of the middle part of the opening, which have longer radii and are struck from centres below the springing level. These arches are conducive to many variations of proportion depending on the variations of the two radii. They may be steep or relatively flat, and in some cases the curvature of the inner arcs is so slight as to appear nearly straight. They are almost indistinguishable from the so-called Tudor arch, in which the inner members are in fact straight, though usually flatter. As the width of windows increased, the variable height of this form was conveniently adaptable to the limiting height of an eaves or parapet.

The three-centred, or Basket arch, so-called because its curve resembles the shape of a basket handle, has lesser arcs at the springings like those of a four-centred arch, between which an arc struck from a centre below the springing line completes the arch.

Segmental window arches also appear to have come into limited use during the early fourteenth century, mainly for two- or three-light windows, though there are larger ones. An arc of a circle, with its radius struck from a single centre appreciably below the springing level, this kind of arch usually has only a low rise. Two- and three-light examples of different styles can be seen at

*Fig. 1 (opposite page): Gothic window arches*
*A: Pointed equilateral.*
*B: Pointed obtuse.*
*C: Pointed lancet.*
*D: Four-centred.*
*E: Three-centred or Basket.*
*F: Tudor.*
*G: Ogee.*
*H: Segmental.*

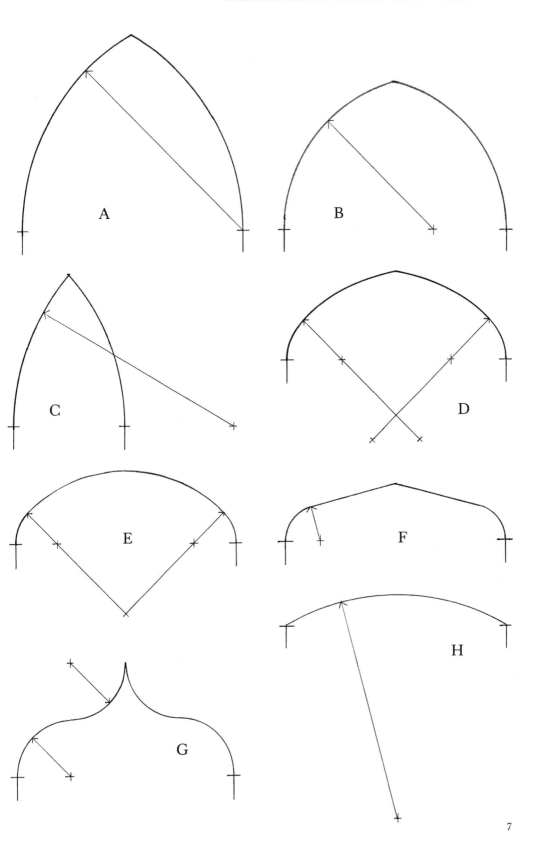

A

B

C

D

E

F

G

H

Helpston, Cambs and South Creake, Norfolk *(Pl. 42d)*. A four-light window at Swinstead, Lincs is segmental-pointed, i.e. a two-centred variant, in which two separate arcs meet at a low apex. In a minor departure in this type, curvature at the apex is not unusual, making the arch effectively three-centred and not easily distinguishable from a truly segmental arch. The fine five-light window at Northborough *(Col. Pl. III)* has this kind of arch. In another variation, the two members of the arch are straight, giving the window a "triangular" head; an instance of this unappealing design, fortunately rare, can be seen at Boothby Pagnell, Lincs.

Until relatively recently, it had been widely accepted that Gothic-style windows with a straight head date from the Perpendicular period. However, it is now evident that they have been used since much earlier times. Lancet lights of equal height in two-light and three-light versions beneath a shared horizontal label moulding were used in the thirteenth century, and thereafter straight-headed windows were not uncommon throughout the Decorated and of course, the Perpendicular periods.

The ogee arch is a form with a double curvature profile. Whereas the arch's lower curves rise from the springings in the normal way, their upper arcs, having radii struck from points outside the arch, are reversed producing an acute point at the apex. Although the ogee curve had been used in the Middle East from much earlier times, it was probably not until the first or second decades of the fourteenth century that it was used on a larger scale in England in door and window arches, though possibly earlier in window tracery. Its first firmly datable occurrence in English architecture is thought to have been in blind tracery on the Eleanor Cross at Hardingstone in Northampton *(Pl. 40a)* built in the last decade of the thirteenth century. Queen Eleanor, the wife of King Edward I, died at Harby in Nottinghamshire in 1290 and her body was taken to Westminster on a twelve-day journey. The Eleanor Crosses were erected during the six years after her death as memorials to her at places on the route where the funeral procession had stopped for the night. Only three of these monuments remain, at Hardingstone, Geddington, Northants and Waltham Cross, Herts.

As an element of design, the importance of the ogee is not so much in the profile of a window's enclosing arch as in the definitive head shape of the arches and sub-arches of individual window lights and the subarcuations within a window's tracery. Comparatively few window arches are ogee-shaped, those that there are being mostly of the smaller sizes like two-light windows of Y-form at Burnham Overy, Norfolk *(Pl. 3a)* and Ravensthorpe, Northants or the three-light reticulated aisle windows at Harlestone, Northants *(Pl. 3b)* and Finedon, Northants *(Pl. 43c)*, though the latter church also has an ogee east window of five lights. Some windows with an otherwise conventional arch, as at Bassingbourne, Cambs *(Pl. 3c)* and Ashwellthorpe,

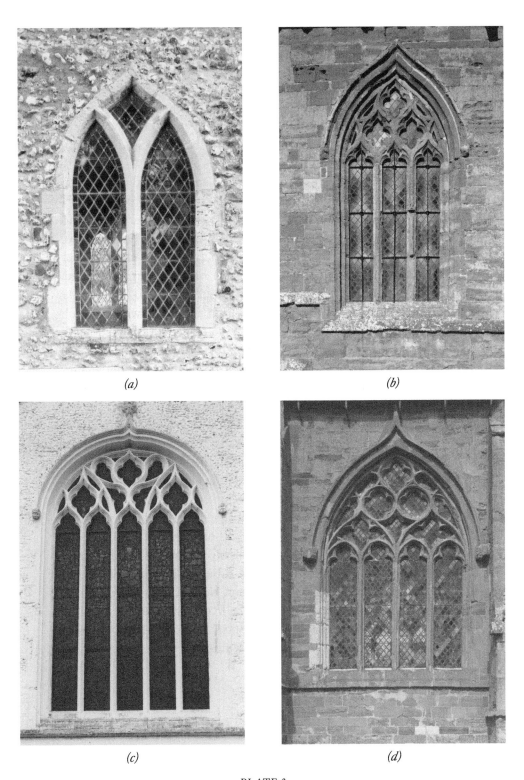

*(a)*

*(b)*

*(c)*

*(d)*

PLATE 3
*a. Burnham Overy   b. Harlestone   c. Basssingbourne   d. Crick*

Norfolk, do have a slight ogee at their apex, and elsewhere several normally arched windows of all sizes exemplified by one with four lights at Crick, Northants *(Pl.3d)* present an ogee appearance through having a hoodmould with an ogee apex.

But the famous big curvilinear windows of Lincolnshire's Decorated churches such as those at Sleaford, Heckington and elsewhere have conventional two-centred arches. It was in their subarcuations and tracery that they showed the full possibilities of ogee arches and curves.

As distinct from the skeletal frameworks described in the next chapter, the styles of medieval Gothic church windows and their tracery may conveniently be classified under the four main types – Lancet, Geometric, Curvilinear and Perpendicular, but within these, several individual trends can be identified. These trends, or sub-styles, will be discussed in detail in later chapters, but the defining characteristics of the main styles are briefly summarised here. The Lancet style is essentially one of simple pointed lights used individually or grouped, and except where a lancet is a light in a multiple window, such tracery that it may have will be a simple foliation forming a trefoiled head; lancet lights with tracery in the head as at Yaxley, Cambs *(Pl.17d)* seem to have been a little later. The basis of the Geometric style is the circle and figures based on its geometry, notably the vesica comprising two arcs and the so-called spherical triangle of three arcs, and in the late phase of the style, foiled figures. Reversed or double curvature is the definitive feature of Curvilinear styles, introducing ogee arches and flowing shapes. By contrast, Perpendicular styles are characterised by straight vertical bars in the tracery.

It is true up to a point that, except in some of the more intricate designs of larger Curvilinear windows, the themes of tracery styles tended to originate in two- and three-light windows and were then adapted to suit larger windows and their subdivisions. Two-light subarcuations of four-light windows, for example, may adopt tracery patterns of two-light windows as at Chartham, Kent *(Col.Pl.IV and Pl.35a)*, and three-light subarcuations often replicate three-light windows as at Terrington St Clement, Norfolk *(frontispiece)* where the three-light intersecting subarcuations of the five-light nave west window echo the three-light windows of the aisles. Central features of large windows are often developments of ideas from smaller windows.

CHAPTER 2

# Skeletal Framework
# of Window Tracery

Two aspects of design contribute to the external appearance of a traceried window: its architectural form creates a visual framework, and independently within that structure, the detail and shapes of the tracery establish the style. Certain framework elements though, like apex circles or intersecting subsidiary arches, may themselves sometimes be part of the tracery style.

Architectural form and primary frameworks are part of the inherent visual structure of all traceried windows, irrespective of their tracery style. As well as the shape of the arch and the number of its lights, other factors that determine a window's visual structure include the stone framework that delineates the principal elements of the composition, the compartmentation and subarcuations that the framework members establish, the extent and manner of subsidiary arches and intersections, and how the curvatures of subsidiary arches – those of individual lights or subarcuated groups – relate to the arcs of the main window arch, or in other words whether they are Coincident or Non-Coincident.

In Coincident windows *(Fig. 2a)*, the outer curves of the subsidiary arches follow the curve of the window arch, and in Non-Coincident ones *(Fig. 2b)*, because they have smaller radii or an ogee shape, the subsidiary arches deviate from the window arch, allowing more space above that may be occupied by a single tracery figure or multiple motifs of any style. Coincidence or Non-Coincidence is applicable not only to a window's side lights but also to its subarcuations relative to the window arch, and to subsidiary arches within subarcuations which may be the same or different from their enclosing arch.

Subarcuations are established when framework members within a window's tracery pattern form a subordinate arch embracing a group of two or more lights, thereby creating distinct visual compartments. Whether

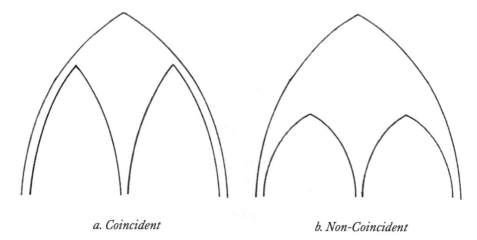

a. Coincident                                          b. Non-Coincident

*Fig. 2  The relationships of the arch curvatures of a window's lights to
the curves of the window arch.
The expressions 'Arch Tracery' and 'Foil Tracery' adopted by Freeman for
these two arrangements are considered confusingly ambiguous and
are not used in this book.*

Coincident *(Pls. 4a and b)* or Non-Coincident *(Pls. 4c and d)*, pointed or ogee, these subsidiary arches can be perceived as separate or intersecting elements of the window's primary framework.

Often standing a little proud of the orders of tracery, the impact of framework members in defining a window's visual structure is usually relatively greater in windows with more than three lights. In two-light windows, apart from the shape of the arch and the tracery technique, the variations of possible visual structure are effectively limited to the alternative configurations of Coincident and Non-Coincident. The former produces the Y-form profile, the apex shape of which is a lozenge with concave sides and convex top curves *(Pl. 10a–c and Pl. 16)*. This common shape also occupies the head of many larger, subarcuated Y-form windows *(Pl. 4b)* with or without further tracery figures within, and occurs frequently with variable proportions in intersecting and other patterns. It appears to have no name, and so for convenience it will hereafter be referred to as a curved diamond.

Since arches of Coincident side lights are usually acute, they will often contain a tracery figure or figures in the apex, above an internal sub-arch (e.g. Pl.25b and c); the sub-arch will of course be Non-Coincident and unless it is clearly subordinate within the side light, it could be mistakenly read as the side light arch. This can also apply to inner lights.

While the considerations relating to Coincident or Non-Coincident lights still apply in three-light windows, more variations of the skeletal framework become possible by means of compartmentation and the grouping of the lights

(a)

(b)

(c)

(d)

PLATE 4
*a. Cowbit   b. Caythorpe   c. Grantham   d. Great Hale*

in subarcuations and intersections, separately or in combination, or through the introduction of prominent central features.

Coincident outer lights of three-light windows define a central compartment that fans out at the top, thereby creating a space that may be occupied by a taller middle light without tracery *(Pl. 20a)* or a shorter one with tracery above *(Pl. 50b)*. In the latter case, the arch of the middle light often matches and aligns with the sub-arches within the Coincident outer lights, creating a false impression of three equal lights. In another variation, three uniform lights may create two subarcuated pairs that are coincident with the window arch and intersect each other *(Pl. 65c)*.

Non-Coincident lights of a three-light window are often but not always of similar sizes and designs or nearly so, and the greater scope allowed by this format produces many variations of intersection and subarcuation with an infinite variety of styles of tracery in the head. Where the apices of outer Non-Coincident lights extend upwards, vertically or curving, they can impart a variety of outlines to the upper part of the central compartment whose shape may then become a visually dominant feature of the skeletal framework.

Although a definitive feature of Early Geometric tracery, a circle in the apex of a window between two lights or subarcuations may also be the primary element of a skeletal configuration that is widely used for windows of all sizes in other tracery styles. In that context, since the window tracery may be of any style, the circle, by virtue of its strong visual impact and irrespective of whether it is clear, foliated or containing other tracery figures, becomes essentially an integral part of the window's visual framework rather than a stylistic feature. There are many two-light Geometric and Curvilinear windows of this form, and four-light Curvilinear examples include Boughton Aluph *(Pl. 50d)* and Thurnham, both in Kent, among others. Grantham, Lincs can show Early Geometric windows with four *(Pl. 4c)*, five *(Pl. 23d)* and six lights, and in the same county, Fishtoft *(Pl. 27c)* and Barton on Humber, St Mary *(Pl. 28d)* have five-light Late Geometric versions; in the latter two windows their two-light subarcuations are Coincident whereas in the Grantham windows they are Non-Coincident.

The simplest frameworks of four-light windows are those in which the individuality and uniformity of the lights make the dominant visual impression, and except in Intersecting tracery, the individual lights will usually be Non-Coincident and continuous through to the window arch, or of equal heights with tracery above, as at Gretton, Northants *(Pl. 62d)*. Many four-light windows though are compound, divided into two subarcuations each of two lights. Subarcuations may be Coincident or Non-Coincident, the latter pointed or ogee; where they are Coincident, as at Caythorpe, Lincs *(Pl. 4b)*, the window's apex space between them will be the frequently occurring curved diamond shape and may contain subordinate figures. In the

(a)

(b)

(c)

(d)

PLATE 5
*a. and b. Sleaford   c. Heckington   d. Ringstead*

four-light windows at Grantham *(Pl. 4c)* with Non-Coincident pointed subarcuations and an apex circle, the tips of the subarcuations penetrate into the spandrels; this often occurs, as in other windows here *(Pl. 23d)* and at Raunds, Northants *(Pl. 12a)*.

In many window designs, there is no clear dominance of the skeletal framework relative to the style of the tracery. This applies particularly to windows with intersecting tracery styles, and in such windows the pattern created by members of the skeletal framework is essentially part of the tracery style, as for example in the east window of the south aisle at Great Hale, Lincs *(Pl. 4d)*; there, four uniform lights, traceried with Late Geometric trilobes, are the elements of intersecting ogee subarcuations that form the window's visual structure.

Two four-light windows at Sleaford are beautiful examples of well-proportioned Curvilinear designs with Non-Coincident subarcuations in which the visual framework and details of style are in ideal balance. In one *(Pl. 5a)*, the subarcuations are pointed and the tips of their arches avoid penetrating the spandrel spaces because the ovate shape of the apex figure, unlike a circle which rests on the arches, conforms to their curves. The other *(Pl. 5b)* has ogee subarcuations and the inner curves of their arches are continued to form a central vesical feature. Ogee subarcuations can of course, only be Non-Coincident.

In the rarer four-light configuration where Coincident subarcuations are the width of only one light, the wider two-light centre compartment becomes a dominant feature of the window.

Broadly, the primary frameworks of five-light windows are expanded versions of those found in three-light types. Five-light Coincident designs include those in which the middle compartment, widening at the top, is flanked by two-light subarcuations as at Snettisham, Norfolk *(Pl. 52b)* or Langham, Rutland *(Pl. 63d)*; those in which three-light subarcuations intersect as at Terrington St Clement *(frontispiece)* or Empingham, Rutland *(Pl. 65d)*; and a less common pattern in which single outer and centre lights are separated by shorter lights below splayed traceried heads, as in the east window at Ingham, Norfolk *(Pl. 52d)*. In these formations, the foliations of the sub-arches in the subarcuations are usually aligned approximately at the springing level of the window arch but the middle light arch may differ from them in height and foliation as in the Snettisham window.

In the simplest of the Non-Coincident five-light forms, the lights run through to the window arch, their foliated arches being their only embellishment, as at Wakerley, Northants *(Pl. 61d)*, but where the arches of the lights align with the base of the window arch, the space above may contain tracery of any style, whether repetitive like the Reticulated style or of freer design. Depending on whether their arches are pointed or ogee and whether

in the latter case the apices are extended upwards to meet the window arch, two-light outer subarcuations leave centre compartments of various shapes that may contain motifs of any style. In larger windows, multiple subarcuations may each embrace two and three lights as at Oundle, Northants *(Pl.31b)* or pairs as at Kislingbury, Northants *(Pl.31c)*, and in designs of this kind, the ogee intersections of the skeletal framework seem to induce a vesical tracery style.

The skeletal frameworks of windows with six or more lights broadly echo the patterns suited to an even or an odd number of lights established by four- and five-light windows, and exploit the increased permutations of subarcuation and intersection that more lights offer.

Another distinctive though visually restless skeletal form could be categorised simply as Asymmetrical. It occurs, for example, when a subarcuation with an odd number of lights appears to be combined with one with an even number beneath a shared asymmetrical arch, as in the five-light transept window at Heckington *(Pl.5c)*, or when the apex of a light or a subarcuation is distorted to accommodate a central feature, as in the similar Coincident five-light east windows at Ringstead *(Pl.5d)* and Cotterstock *(Col.Pl.XIV)*, both in Northamptonshire. These quirks are more noticeable in the visual structure of larger windows but there are instances of asymmetry in three-light windows, examined in Chapter 6.

CHAPTER 3

# Origins and Techniques
# of Tracery

## PROTO-TRACERY

Although there is discussion as to which may have been earlier, architectural historians agree that windows at Westminster and Binham Priory, Norfolk, datable from about 1240, represent the earliest use of Geometric Bar tracery in England, but those are mature works by masters of the first rank. The inclusion in them of foliated figures and tracery bars shows an abrupt change from the simple Lancet style and was, no doubt, influenced by French examples. In smaller churches by lesser masons development is likely to have been more gradual. The evolution of Plate tracery has been suggested as the conduit by which such a transition might have happened, but that implies that two or more lights would first have been embraced under one arch. While that may be so, a stage of progression towards the new style may alternatively have been the introduction of a decorative piercing in a wall as a separate entity above lancet lights; there is one such arrangement in the chancel east wall at Stibbington, Cambs *(Pl.6a)* where, in contrast to the then orthodox arrangement of three stepped lancets, two tall lancets are widely spaced and a large independent quatrefoil opening located in the gable above them. In a development of this idea, in a side window at St Mary's, Barton on Humber *(Pl.6b)*, the three separate elements of the composition are united; an encircled quatrefoil rests directly on the linked hoodmoulds of two lancets unified as a single window – a combination that in effect uses the same elements as the aisle west windows at Binham but without an embracing arch.

It is arguable that a simple trefoil forming the head of a lancet, as in windows at Grasby, Lincs *(Pl.8a)* or Clipsham, Rutland *(Pl.6c)*, is a rudimentary manifestation of tracery, though strictly it is neither Plate nor Bar tracery;

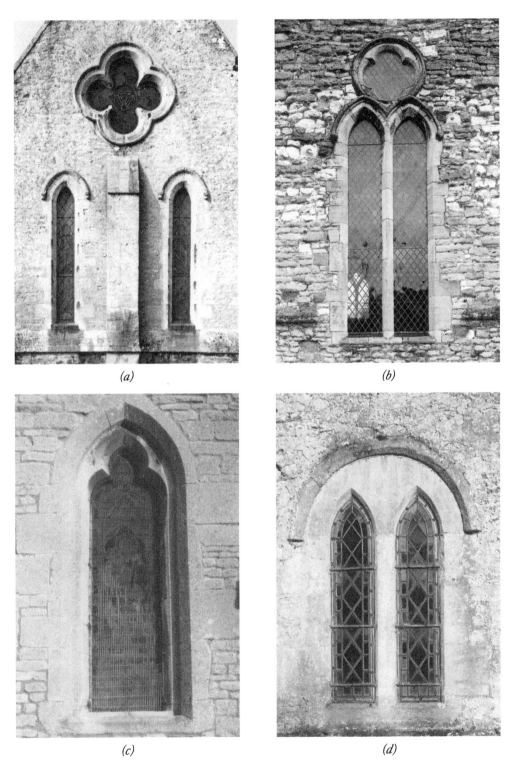

*(a)*

*(b)*

*(c)*

*(d)*

PLATE 6
*a. Stibbington   b. Barton on Humber, St Mary   c. Clipsham   d. Tansor*

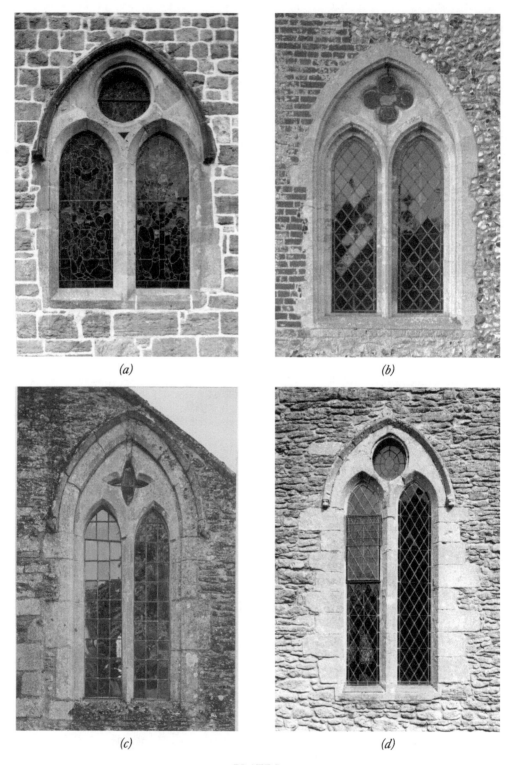

(a)

(b)

(c)

(d)

PLATE 7
*a. Lynchmere   b. West Harling   c. Carlby   d. Glapthorn*

however, where the cusps are subordinate, i.e. recessed as an inner order, and the small spandrel between the cusp and the arch is pierced as at Scotton, Lincs *(Pl. 10b)*, that could be regarded as an elementary form of Bar tracery, though not necessarily its earliest.

## PLATE TRACERY

When, during the early twelfth century, separate lancets were unified as couplets or triplets beneath a shared arch or hoodmould to become the lights of a single window, the window headwork beneath the hoodmould would often be of dressed stone like that of a window at Tansor, Northants *(Pl. 6d)* where two pointed lights with a wide flat mullion between are embraced beneath a semi-circular hoodmould. Plate tracery evolved when this solid headwork, either made from a single dressed stone slab or built up from a small number of separate ashlar pieces, was perforated by a simple aperture such as a roundel, quatrefoil or vesica. Plate tracery is more commonly a feature of two-light windows in which the arches of the lights are non-coincident with the window arch. In this most basic form, the aperture in the stonework appears as if simply cut out in the manner of fretwork, though perhaps given chamfered edges. A roundel at Lynchmere, Sussex *(Pl. 7a)*, a quatrefoil at West Harling, Norfolk *(Pl. 7b)*, a cruciform quatrefoil at Carlby, Lincs *(Pl. 7c)* and a vesica at Glapthorn, Northants *(Pl. 7d)* are simple perforations of this kind.

Instead of taking the form of a geometrical figure, the headwork perforation of some Non-Coincident windows was made to occupy the whole of the space above the lights enclosed by the pointed window arch, and the resulting shape of the piercing then became a curved diamond with awkward pointed notches at its bottom corners. In a window of this kind at Grasby *(Pl. 8a)*, the notches were simply treated as a tapering chamfer on the surface of the stonework but in a similar context at Dowsby, Lincs *(Pl. 8b)* the inner curves of the lights' arches are extended to meet the window arch, creating small triangular sinkings at these points. The same artifice is used in a window at Greatford, Lincs *(Pl. 8c)* but there the diamond figure in the head is foliated.

Although consideration of belfry openings is outside the scope of this book, it should be mentioned that flat Plate tracery in them is more common than in church windows and its use in belfries continued much later. This is probably because there was no need for glazing in belfry openings and also because many nave and chancel windows of this kind would probably have been replaced later with larger ones.

## SUNK-SPANDREL TRACERY

Flat Plate tracery of the thirteenth century with a simple oculus perforation in flat headwork is comparatively uncommon, but the carving of unpierced

sinkings in the spandrels and other small spaces around the figure in the window-head stonework was a development soon introduced and widely used, and it continued in later windows. Overlooked in many architectural books and glossaries, the practice could perhaps usefully be differentiated as a distinct tracery category, and could logically be termed Sunk-spandrel tracery.

In the aisle west window at Etton, Cambs *(Pl.9a)*, quite deep recesses in the spandrel spaces between the pierced apex figure and the enclosing arch throw the outlines of the Non-Coincident arches of its lights and the figure itself into relief, and in a further refinement that soon became the normal practice, the edges of such sinkings were chamfered as in the chancel windows there. Different applications of unpierced sinkings in a Non-Coincident two-light window at Honington, Lincs *(Pl.22a)*, where all the window headwork is formed from a single stone, at Northborough and Hallaton, Leics *(Pl.9b)*, and in a later one at Muston, Notts *(Pl.9c)*, or in a three-light window at Barrowden, Rutland *(Pl.9d)*, suggest that they are neither true Plate tracery nor Bar tracery, although in some cases this mode is combined with Bar tracery.

Coincident two-light windows do not of course have side spandrels, but they may nevertheless have Sunk-spandrel tracery. As windows at Great Addington, Northants *(Pl.10a)*, Scotton *(Pl.10b)*, and Norton Disney, Lincs *(Pl.10c)* show, an encircled apex figure can leave an unpierced sinking of concave triangular shape below.

Plate and Sunk-spandrel tracery cannot be assumed to have been used only for the earlier geometric styles or exclusively to predate later styles of tracery. The vesica in the Glapthorn window and the trefoil at Bedingham, Norfolk *(Pl.24c)* are figures more characteristic of the Late Geometric style of about half a century or thereabouts later than the earliest Plate tracery. Techniques that have been widely regarded as thirteenth-century may therefore have extended into the fourteenth.

## BAR TRACERY

In due course, recesses of Sunk-spandrel tracery penetrated the stone to become piercings for glazing, initially quite small as in windows at Grafton Underwood, Northants *(Pl.10d)* and West Walton, Norfolk *(Pl.22d)*. When the stonework members between the piercings and the lights or the figure in the head acquire a moulded cross-section similar to that of the mullions, the principle of Bar tracery becomes established. Bar tracery is moulded stone ribwork or bars of such sections in a window head, forming patterns that delineate decorative piercings or subdivide larger lights for glazing. The shapes of the piercings can vary from geometrical figures and trefoils, quatrefoils and multifoils to amorphous ogee shapes or rectilinear panels, and the ribwork is often foliated, having lobes or foils between projecting cusps. In many

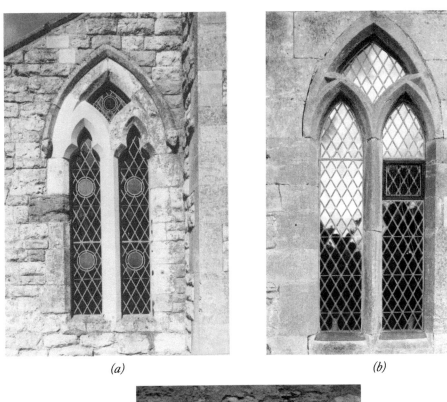

*(a)*                                                                  *(b)*

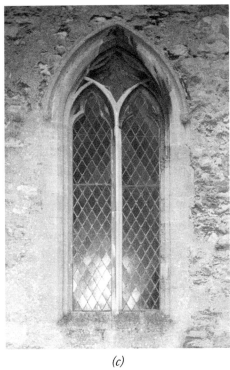

*(c)*

PLATE 8
*a. Grasby   b. Dowsby   c. Greatford*

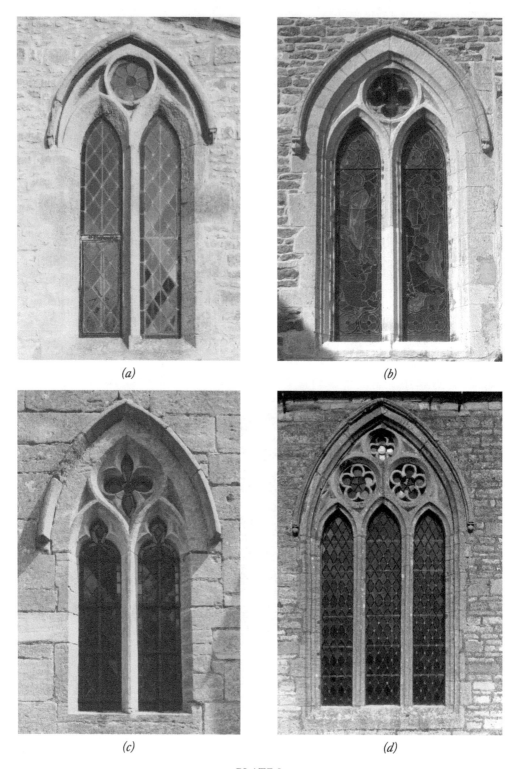

(a)

(b)

(c)

(d)

PLATE 9
*a. Etton   b. Hallaton   c. Muston   d. Barrowden*

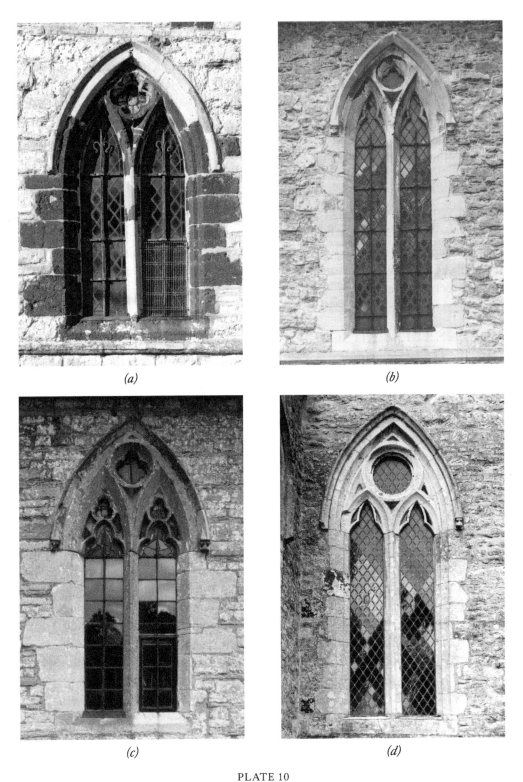

PLATE 10
*a. Great Addington   b. Scotton   c. Norton Disney   d. Grafton Underwood*

instances trefoil cusping within window lights is of a circular section and appears almost independent from them; bar cusping of this kind is common in early tracery as at Scotton *(Pl.10b)* or Stanion, Northants *(Pl.14b)*.

Bar tracery was invented in France and first used at Rheims in the early thirteenth century, and was introduced in England about forty years later. It was the progressively developing shapes of the figures created by the ribwork of Bar tracery that became the defining features of the successive English window tracery styles until the Reformation.

## STRAP TRACERY

Certain early tracery appears to be formed with thin flat stone bands rather than from moulded stone ribwork, but this technique is not common. A round-lobed trefoil supported by a pointed trefoil sub-arch within the lancet lights of the window at Norton Disney *(Pl.10c)* provides one example of this tracery technique and there is more, within circles, at Caythorpe *(Pl.11a)*. The tracery plane is recessed relative to the face of the mullions.

## COLONNETTE AND SCULPTURAL TRACERY

While the pattern of tracery ribwork may be seen as a continuation or branching of a window's mullions, there are some instances where the mullions terminate with small capitals, breaking the flow from mullion to tracery although the cross-sections of the members may be the same. In these instances, the mullions become in effect small colonnettes and are used in windows of all sizes, nor are they specific to any particular period or style; they can be seen for example in a Geometric window of two lights at Swaton, Lincs *(Pl.11b)*, also in three-light Curvilinear windows there, and in a Perpendicular three-light one at Cavendish, Suffolk. There are larger multi-light windows with colonnette mullions at Grantham *(Pl.4c)* and Sleaford *(Pl.5a)*, Geometric and Curvilinear respectively.

In addition to colonnette mullions, chancel windows at Merton, Norfolk *(Pl.11c)* have another unusual sculptural quality: the spandrels between the arches of the lights and the tracery, and the residual areas between the trefoil and trilobe tracery motifs are unpierced but have small sinkings of shapes that follow the irregular shapes of the spaces, similar in manner to Sunk-spandrel tracery. The sense of solidity that this gives makes a striking contrast with the lightness of normal tracery.

In a rare, if not unique, departure from conventional Bar tracery usage, sculptured elements take the place of some of the normally moulded bar tracery members in the incomparable early fourteenth-century five-light east window at Barnack *(Pl.11d)*. Between its acute stepped lancet lights, window mullions of conventional section extend up to the window arch, but instead of meeting it in the normal way, they terminate with sculptured finials, and

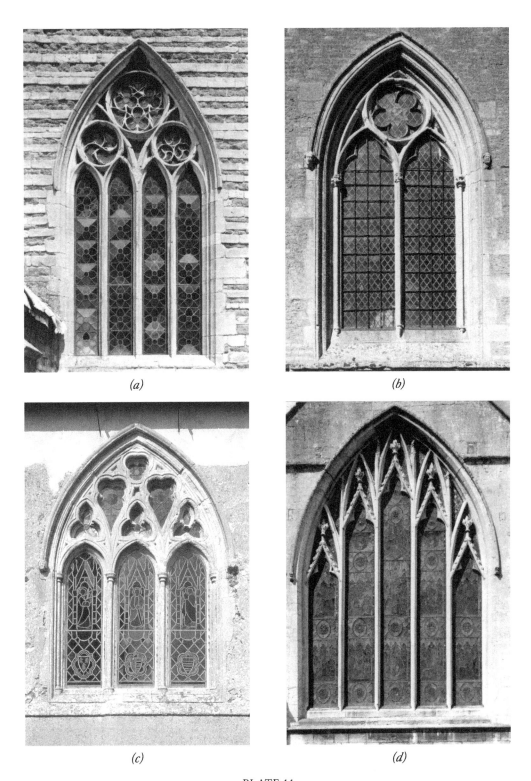

PLATE 11
*a. Caythorpe   b. Swaton   c. Merton   d. Barnack*

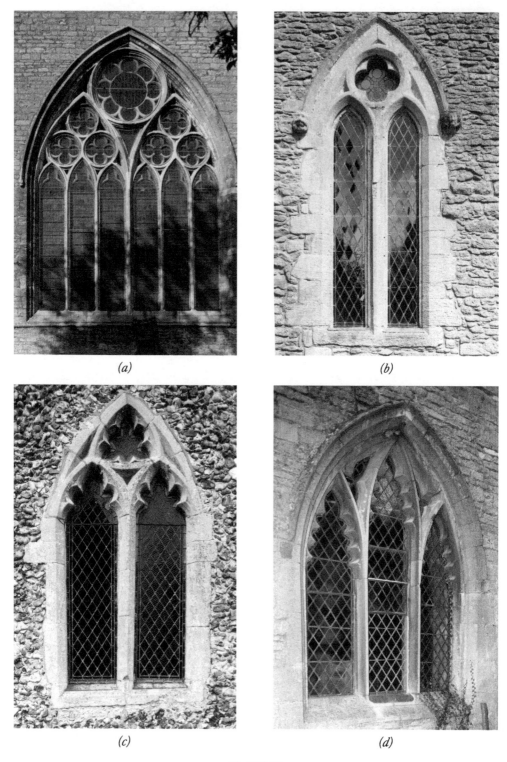

(a)

(b)

(c)

(d)

PLATE 12
*a. Raunds   b. Glapthorn   c. Rockland St Peter   d. Castle Bytham*

within the head of each light, a small gabled canopy, crocketted and crowned with a knopped finial, encloses a pointed trefoiled sub-arch.

## DROP TRACERY

The arches of the individual lights of most windows are usually, but not always, at the same level, and that generally coincides with the springing of the window arch. Where the window arch has only a shallow rise as in many four-centred and segmental arches, e.g. Pls.63c and 20d, there is insufficient space above their springing level for tracery. In those cases the arches of the lights are lowered to spring from a level below that of the main arch, making space for tracery above them; such tracery is known as Drop tracery.

## THE HIERARCHY OF TRACERY

The glazing plane of church windows is normally much closer to the outer face of the wall than the inner, with generous splays on the internal reveals. Externally, small gradations or recessions in the window stonework known as orders occupy the depth between the wall face and the glass line and, usually moulded, they form the elements of a window's tracery; they can be differentiated as follows:

*Framework Mouldings.* These are the principal stone members that delineate the main elements of a window's visual structure such as its subarcuations, any focal central feature such as a circle, or the principal mullions in Perpendicular windows; they are more typically elements of larger windows and are usually aligned on the wall plane.

*Tracery Mouldings.* This order delineates the window's mullions, the pattern of its lights and the tracery figures. These elements are normally aligned in the same plane, although Strap tracery is recessed relative to the mullions *(Pl.10c)*. In windows with framework mouldings, the tracery mouldings are recessed relative to them.

*Foliation Mouldings.* These are recessed within the tracery elements and comprise the foliations or cusps that elaborate the tracery motifs or the lights. They may be worked on the tracery mouldings *(Pl.12d)* or take the form of bar cusping *(Pl.10b)*.

The simplest foiled lancet windows like the one at Clipsham *(Pl.6c)* have only a single order of stonework between the wall face and the glazing line, but the subordinate cusping at Stanion *(Pl.14b)* or Sudborough, Northants *(Pl.14c)*

represents an inner plane within the order established by the mullions. It was however only after the introduction of the Bar tracery of the Geometric style that a recognisable hierarchy of tracery came into being. Most windows of two or three lights with Bar tracery have two orders of mouldings, tracery and foliations, but larger windows often have three. A fine example of the latter is the six-light window at Raunds *(Pl.12a)* in which the *framework* members define two three-light subarcuations and the centre circle, the *tracery* elements delineate the lights and the smaller circles within the subarcuations, and the *foliations* provide subordinate detail within the lights and circles.

There are though windows with a single order of tracery, and this seems unrelated to chronology or necessarily to economy. Foliations slightly recessed from but monolithic with the window stonework on the wall plane, as in the sunk-spandrel head of a window at Glapthorn *(Pl.12b)*, or worked directly on the window stonework on the wall plane, as in the Sunk-spandrel tracery of a two-light spherical triangle window at Rockland St Peter, Norfolk *(Pl.12c)*, are datable to the late thirteenth and early fourteenth centuries. Concurrently and later, foliations were also worked directly on recessed arch stonework, rather than as a subordinate order, as in the three-light stepped lancet west window of the north aisle at Castle Bytham, Lincs *(Pl.12d)*. These were followed by the ubiquitous single-order plain Y-tracery and Intersecting styles with no foliations.

## MULLION PROFILES

The windows of earlier medieval stone churches were single openings; they were usually narrow but the stonework of their reveals, inside and out, was splayed to allow maximum admission of light. When multiple lights were introduced, upright stone members between them naturally followed. In some early windows as at Tansor *(Pl.6d)* and Castle Bytham *(Pl.19b)* these were quite wide, and although chamfered to echo the splays of the window reveals, their flat face still gave the visual impression of being short sections of wall or part of the wall plane rather than a shaft or column between the lights. However, reduction of the width of the member's face to the minimum practicable, in conjunction with chamfers inside and out, produced a true mullion of diamond shape of the kind seen in other early two-light windows such as those at Little Casterton, Rutland *(Pls.15b and c)*, Longthorpe, Cambs *(Pl.14d)*, Honington *(Pl.22a)* and many others. The diamond cross-section though, was not restricted to early windows, and this profile was widely used later in lancet and intersecting patterns, particularly in designs without foliations, persisting well into the fourteenth century and later.

By contrast with the Honington window, comparable two-light and three-light windows at Castor, Cambs *(Pl.22b)* have hollow-chamfered mullions; these are similar to diamond mullions except that the chamfers are concave

instead of flat. This profile became universal and continued until the end of medieval tracery, when, in the later sixteenth century it was superseded by the ovolo section in which convex quadrant mouldings take the place of the hollow chamfers. The ovolo became a standard detail for Elizabethan domestic and seventeenth-century Gothic-derived windows.

Concurrently with these thirteenth-century developments, mullions with a roll moulding on the face appeared in some windows of Lancet style as at Warmington, Northants *(Pls. 18c and d)* and in those with Bar tracery as at West Walton *(Pl. 22d)*. In this type, the roll moulding is usually repeated on the window reveals and continues round the heads of the lights. This pattern or variations of it also continued to a lesser extent in Curvilinear and Perpendicular windows.

No clear chronology for these mullion profiles emerges; all appear to have been in use in the thirteenth century and continued for long afterwards.

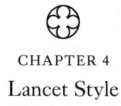

CHAPTER 4

# Lancet Style

Following the Transitional Period in England during which the Gothic style of architecture was superseding the Anglo-Norman Romanesque, and before the introduction of window tracery in the mid-thirteeenth century, the windows of early stone churches were narrow single-light openings with a pointed arch, known as a lancet. The style that evolved from this simple shape, its grouping and its combination into multi-light windows is therefore a window style rather than a tracery one and is one of those in which the architectural form is the dominant feature of the style.

The lancets were often very tall relative to their width, like one in the tower at Chesterton, Cambs *(Pl. 13a)* which also has in its external stonework a square rebate that might originally have accommodated the frame of a translucent fabric screen. A lancet window at Swaton *(Pl. 13b)* has a similar rebate, and like many others elsewhere, also has a hoodmould with decorative stops. Twin east windows in the chancel at Great Casterton, Rutland show a further degree of embellishment *(Pl. 13c)*; the window aperture is recessed a few inches from the wall face within a slightly wider opening flanked by shafts with stiff-leaf capitals supporting a moulded arch.

Before long, lancets with cusping in the head appeared, initially trefoiled. The earliest date of trefoiled lancets is uncertain, and there does not appear to be any significant difference in date between them and simple pointed lights, nor between foliations worked on the arch stonework and those with subordinate cusping. Though there are exceptions, in earlier windows, trefoiled lancets in general came before cinquefoiled ones; the latter, like one in the round tower at Syleham, Suffolk, are not common before the fourteenth century. The foliations took two forms: they might be worked directly on the window arch stonework, or they could be in the form of subordinate cusping.

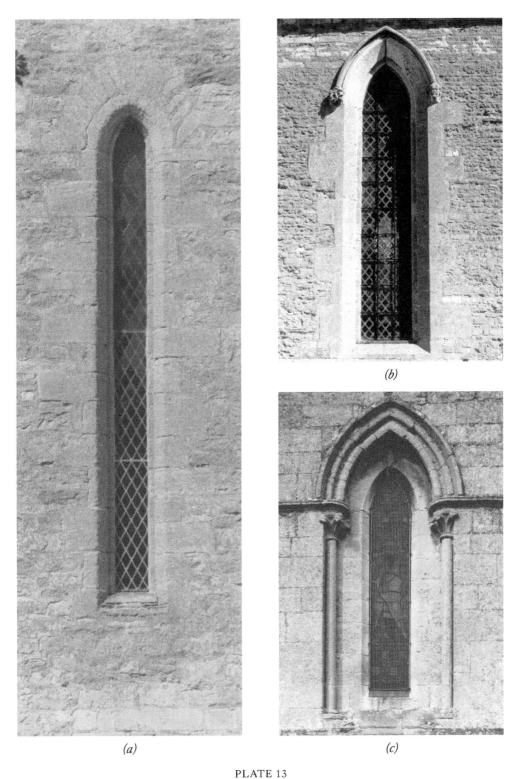

*(a)*

*(b)*

*(c)*

PLATE 13
*a. Chesterton   b. Swaton   c. Great Casterton*

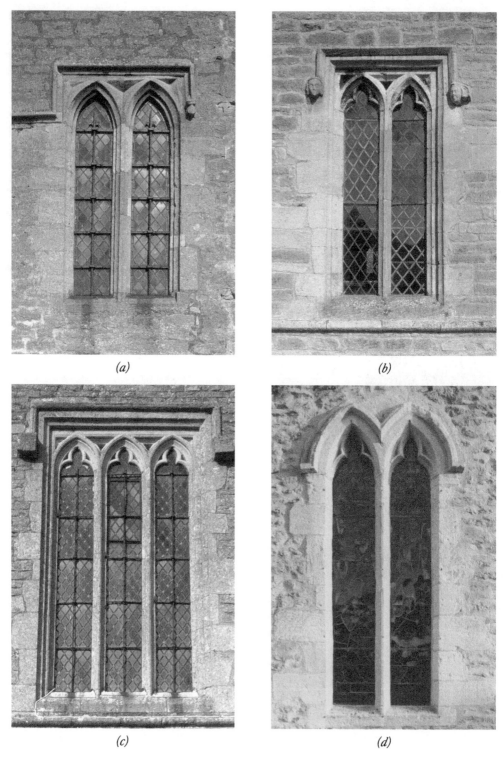

*(a)*

*(b)*

*(c)*

*(d)*

PLATE 14
*a. and b. Stanion   c. Sudborough   d. Longthorpe*

The west window in the tower at Clipsham *(Pl.6c)* and a small low-side window on the north side of the chancel at Longthorpe are instances of early single lancets with foliated arches; both have trefoils worked on their arch stonework.

At Stanion, simple pointed paired lancets in one window *(Pl.14a)* and a trefoiled pair in another *(Pl.14b)* are unified beneath horizontal hoodmoulds, and the neighbouring church of Sudborough has a similar combination of three lights *(Pl.14c)*. Paired trefoiled lancets at Longthorpe *(Pl.14d)* have individual but linked pointed hoodmoulds. These thirteeenth-century trefoiled windows all have subordinate cusping, with pointed apex lobes. The Longthorpe windows may be from 1260-70.

Where a pair of lancets is unified beneath a shared pointed window arch, the Non-Coincident arrangement seems to have come first. The space above the lights is more usually occupied by a geometric figure as at Woodnewton, Northants *(Pl.15a)* where two lights with subordinate cusping support a very weather-worn multifoiled circle. By virtue of their shape, trefoiled lancets are rarely Coincident, but trefoils within Coincident pointed lights do occur; in an early couplet at Little Casterton *(Pl.15b)*, whereas the arch of each light at the wall face is pointed and follows the window arch, it is worked as a trefoil at the glazing line. At the same church similar trefoils occur in Non-Coincident pointed lights of a companion window *(Pl.15c)* whose unencircled quatrefoil occulus is a Late Geometric motif (see Chapter 5). In both these windows, the whole window-head comprising the arches of the lights and the apex figures is cut out of a single stone, and so although without the characteristic flat appearance of Plate tracery, this is technically a form of it.

The inner arcs of Coincident lancets of a two-light pointed window will naturally establish a Y-form and define a curved diamond shape in the apex between them *(Pls.10a-c and Pl.16)*. Where that configuration is without tracery in the lights or figures in the head as in Pl.36c, it is more usually understood as Y-tracery, the two-light version of the Intersecting style (see Chapter 5). Many Coincident two-light lancet windows of Y-form though, do have tracery in their lights and apices, and some of these probably predate the definitive Y-tracery and Intersecting styles. They include types with Sunk-spandrel tracery, with or without tracery in their lights, with an encircled figure in their apex such as those at Great Addington *(Pl.10a)*, Scotton *(Pl.10b)* and Norton Disney *(Pl.10c)* referred to in Chapter 3. However, windows of this pattern with mature Bar tracery, like one in the south aisle at Threekingham *(Pl.16a)* and comparable ones with pointed trefoils as at Ufford, Cambs *(Pl.16b)*, are more likely to be later and contemporary with the Intersecting style.

Two-light windows with a Coincident Y-form framework also persisted

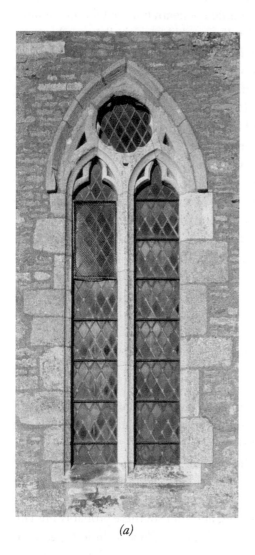

(a)

(b)

(c)

PLATE 15
*a. Woodnewton   b. and c. Little Casterton*

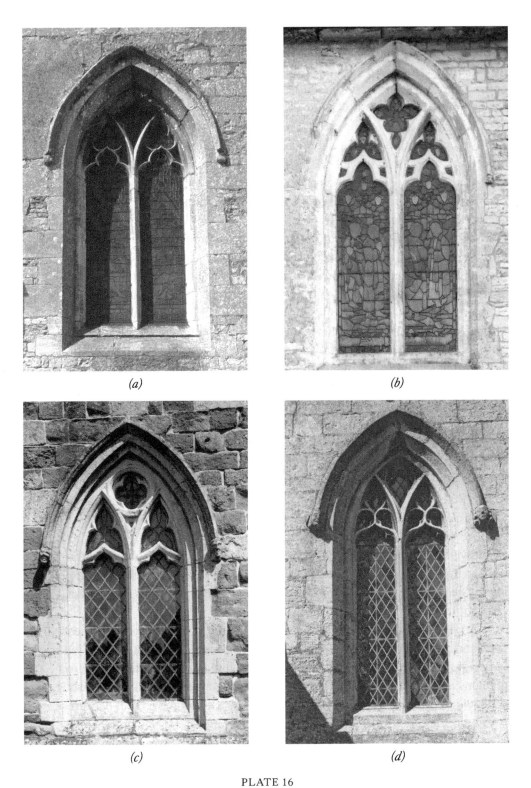

*(a)*

*(b)*

*(c)*

*(d)*

PLATE 16
*a. Threekingham  b. Ufford  c. Burton Lazars  d. Bainton*

in later styles with, for example, ogee or Curvilinear tracery in the lancets, as at Burton Lazars, Leics *(Pl.16c)* and Bainton, Cambs *(Pl.16d)* respectively, and with foliations or a variety of different figures in the curved diamond apex. These later instances demonstrate the continuation of the lancet as a basic standard element of Gothic windows well beyond the period of the Lancet style.

A grouping of three individual lancets, the central one taller, was a common composition in the east wall of thirteenth-century churches. In one such typical instance at Polebrook church *(Pl.17a)*, three lancets, each with their own hoodmould, are separated by areas of wall between them of about twice the width of the lights. In a similar arrangement at Castle Rising church, Norfolk *(Pl.17b)* where the windows have shafted jambs with small capitals at their springings, they are so close to each other that the hoodmould of the taller central one virtually overlaps those over the side units but they are still separate windows; the space between them, though much narrower than at Polebrook, is still a section of wall rather than a mullion. In other examples of the Polebrook configuration elsewhere, the hoodmoulds of each window are linked by short horizontal mouldings of the same section between the windows. The inevitable culmination of this tendency to unify three windows under a shared hoodmould is shown at Tinwell, Rutland *(Pl.17c)* where the divisions between the three windows cease to be narrow wall strips and become mullions and, with the hoodmoulds now joined and a common window cill, a stepped three-light window is formed. Exemplifying continuity from one style to another, a window of similar form at Yaxley *(Pl.17d)* is an instance of a persisting early Lancet style embodying later tracery; the subordinate tracery in its lights is Late Geometric comprising an unencircled trefoil with round lower lobes and a pointed top one above a trefoiled sub-arch – a pattern similar to that in the lights of the sunk-spandrel window at Norton Disney *(Pl.10c)* referred to above except that there the trefoil's top lobe is round and the whole of the window headwork including its recessed tracery is carved from a single stone. The pattern was also used as sidelight tracery in later styles.

The next stage of development was the enclosure of three or more stepped lights under a common hoodmould. In its simplest form, this occurs at Nassington, Northants *(Pl.18a)* where three pointed lancet lights with plain mullions between are grouped beneath an almost semi-circular but apparently three-centred enclosing hoodmould. Oundle has a five-light version beneath a pointed hoodmould *(Pl.18b)*. More elaborate interpretations of the same idea are seen in two versions with pointed hoodmoulds at Warmington *(Pls.18c and d)* where plain stonework occupies the spandrel spaces, the lights being unified by a shared hoodmould. In the more luxuriant window of these two, lavishly embellished with dogtooth mouldings, pairs of engaged shafts at

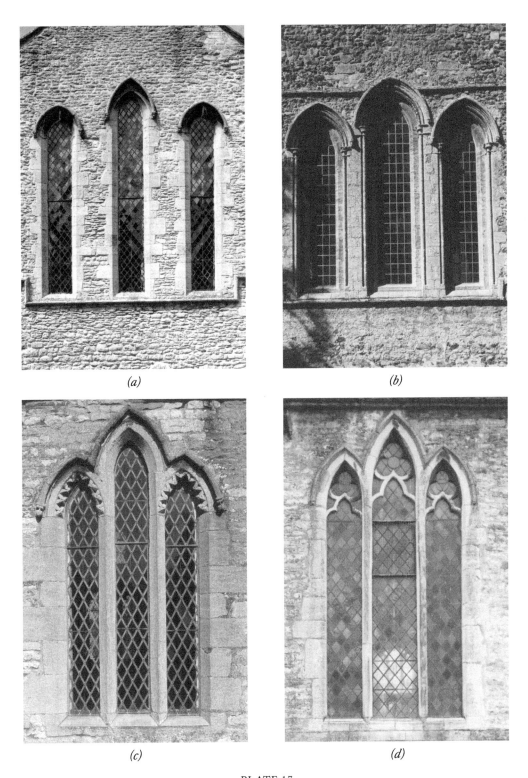

(a)

(b)

(c)

(d)

PLATE 17
*a. Polebrook   b. Castle Rising   c. Tinwell   d. Yaxley*

39

the jambs create recession of the window plane so that in effect the hoodmould becomes the outer member of a window arch. At Billingborough, Lincs *(Pl.19a)* the same arrangement is followed but with clear distinction between the window arch and the hoodmould. A window at Castle Bytham *(Pl.19b)* is similar to the Billingborough one except that the curves of its outer lights are Coincident with the curve of the window arch, and unusually, its spandrel stonework is carved with curious small blank trefoils and quatrefoils. This format is now only a small step from the spandrels being pierced, and with the mullions and stonework members between the lights and piercings acquiring moulded cross-sections to become Bar tracery, windows with three stepped lancet lights, as at Blundeston, Suffolk *(Pl.19c)*, or five, as in the east windows at Gaddesby, Leics and Etton *(Pl.19d)*, evolved. It was then not long before cusping was introduced in the heads of the lights, creating trefoiled arches as in the outer lights of a three-light window at Burton Coggles, Lincs *(Pl.20a)*, cinquefoiled lancets as at Beeston St Lawrence, Norfolk *(Pl.20b)* and, as in the north aisle west window at Castle Bytham *(Pl.12d)*, multifoiled lancets. In a variation of the visual structure in which a window's outer lights are Coincident with the window arch, the cinquefoiled, centre light of the Burton Coggles window has the curves of its arch struck from smaller radii than the outer lights. The same visual structure is followed in a window at Tansor *(Pl.20c)* but its foliation differs in that the heads of all three lights contain simple subordinate cusped trefoils, rounded in the outer lights and pointed in the centre one – another application of simple Bar tracery in a Lancet-style window.

Tracery figures in the apices of lights above sub-arches like those in two-light windows *(Pls.16a–d)* also occur in three-light windows; sometimes, above ogee sub-arches, this may be two-stage tracery as at East Malling, Kent *(Pl.20d)* where, under a segmental window arch, the lights are Non-Coincident. The tracery patterns seen in the lights at East Malling were often used in the outer lights of three-light windows of later styles, and their combination as Coincident outer lights with an ogee light in the centre compartment was not uncommon.

Before the fourteenth century, the arches of window lights and their sub-arches were mostly simple pointed or trefoiled with round or pointed lobes, and occasionally cinquefoiled, the latter becoming more common thereafter. Ogee versions of these patterns developed, and concurrently with the non-ogee versions, continued in the Curvilinear and Perpendicular styles. The foliation style of the arch of a light or its sub-arch is therefore of only limited value for dating or assessing the relative chronology of window patterns.

The lancet styles described above were prevalent during the thirteenth century and the early years of the fourteenth, but as a basic element of pointed windows, the lancet form itself persisted in other contemporary and later styles

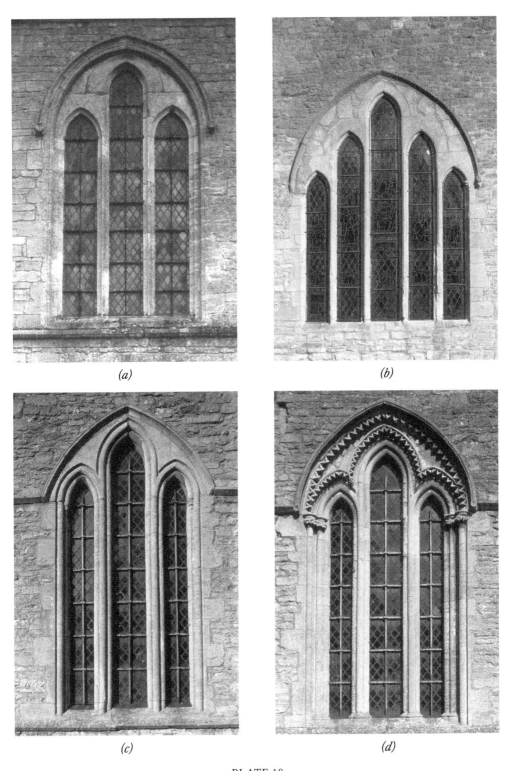

*(a)*　　　　　　　　　　*(b)*

*(c)*　　　　　　　　　　*(d)*

PLATE 18
*a. Nassington   b. Oundle   c. and d. Warmington*

41

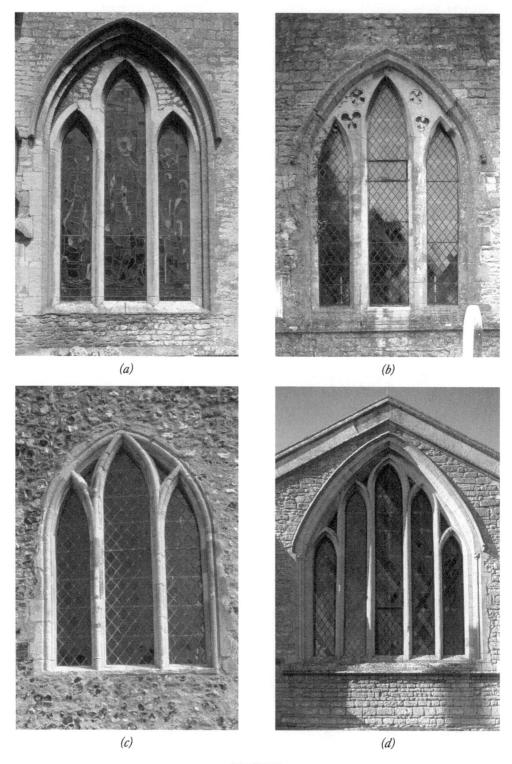

(a)

(b)

(c)

(d)

PLATE 19
*a. Billingborough   b. Castle Bytham   c. Blundeston   d. Etton*

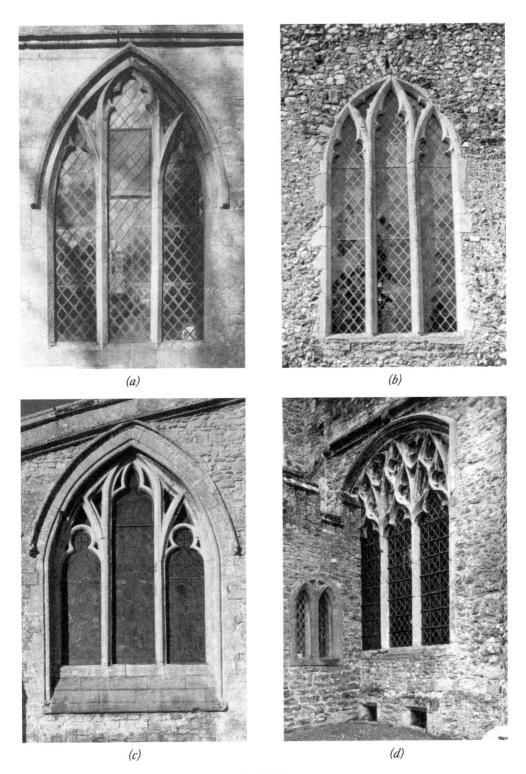

PLATE 20
*a. Burton Coggles   b. Beeston St Lawrence   c. Tansor   d. East Malling*

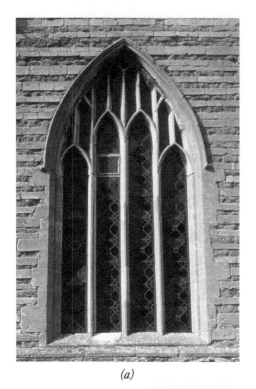

*(a)*

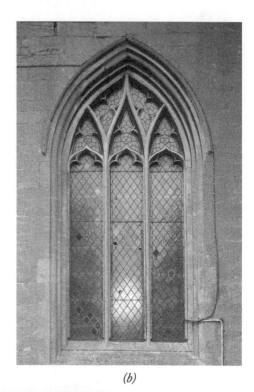

*(b)*

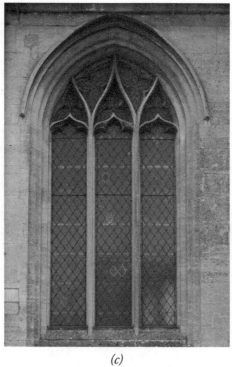

*(c)*

PLATE 21
*a. Caythorpe   b. and c. Great Hale*

as exemplified in an early Perpendicular window at Caythorpe *(Pl. 21a)* where four unfoliated lancets are the dominant features. The lancet was also a natural element of intersections and in subarcuations of multi-light windows.

It is debatable whether a window light with an ogee arch should be considered as a lancet, but in certain cases where the arch is acute and its reverse curvature so slight as to be virtually coincident with the window arch, it may perhaps be appropriate to do so. In two similar but not identical Coincident three-light windows of lancet form in the north aisle at Great Hale, acute ogee lights containing flatter ogee sub-arches are introduced. The one in the west wall *(Pl. 21b)* has normal pointed outer lancets but its centre light is extended in ogee shape up to the apex of the window. The other, in the north wall *(Pl. 21c)*, follows the same pattern; its outer lights are also ogee, but being almost coincident, have necessitated the inclusion of thin stone filler pieces between their reversed upper curves and the enclosing window arch.

CHAPTER 5

# Geometric Tracery
# Styles

## EARLY GEOMETRIC

The emergence of the Geometric tracery style, regarded by some modern writers as Early Decorated of pre-ogee times, which flourished during the second half of the thirteenth century, coincided with the introduction in England of Bar tracery, the medium in which it and later styles were normally expressed; not always though, as windows with Sunk-spandrel tracery show *(Pl.9d)*. The predominant feature of the Early Geometric style is the circle, plain or foliated. Circles are arranged in simple, usually pyramidal, patterns in which the individuality rather than confluence of the parts creates a static visual impression. The elements of a Geometric composition are non-directional figures and where they meet they simply touch, rather than grow out of each other; the absence of foliations in the spandrels and in minor residual piercings tends to affirm their separateness.

The arches of the lights of Geometric windows may be pointed or cusped and they are usually Non-Coincident, though Coincident subarcuations occur in windows of more than three lights.

A Non-Coincident two-light window at Honington *(Pl.22a)* and three-light windows in the south transept at Castor *(Pl.22b)* typify the simplest Geometric design: they have plain pointed lights and tracery of circles without foliations, and in the Honington window the spandrels are unpierced and the whole headwork is fashioned from one piece of stone. Development from the simple unfoliated circle above pointed lights can readily be recognised in many two-light windows: Folkingham, Lincs *(Pl.22c)*, for example, has a trefoil in its circle, West Walton *(Pl.22d)* a quatrefoil and at Swaton *(Pl.11b)* where the lights are trefoiled and the mullion and jambs shafted, the circle is cinquefoiled.

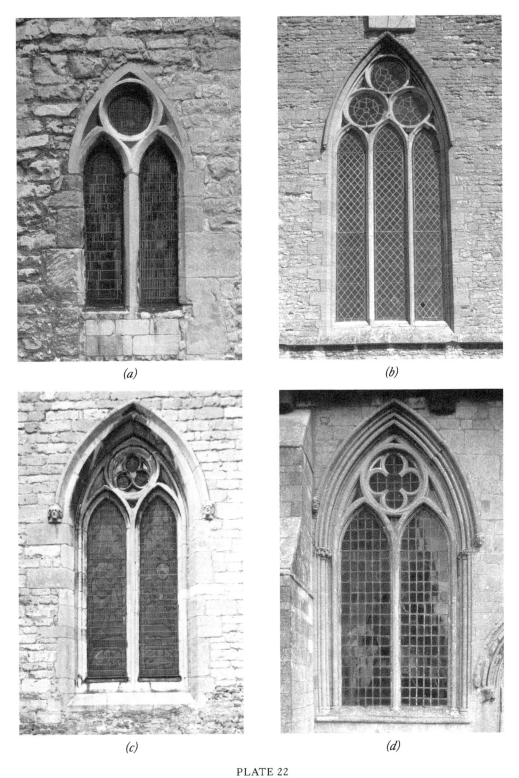

PLATE 22
*a. Honington   b. Castor   c. Folkingham   d. West Walton*

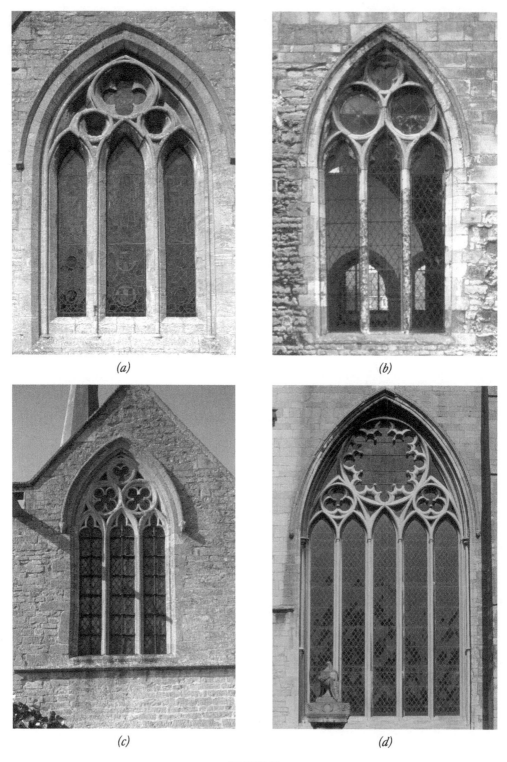

(a)

(b)

(c)

(d)

PLATE 23
*a. Castle Bytham   b. Barton on Humber, St Mary   c. Stanion   d. Grantham*

Three-light windows follow a comparable progression: in a window at Ketton, Rutland that is otherwise similar to the one at Castor, the circles are trefoiled, and at Castle Bytham *(Pl. 23a)* the unusual rather heavy-handed east window, still with Sunk-spandrel tracery, has small unfoiled circles between its lights and a large quatrefoiled circle in the apex. In the more orthodox arrangement the lower circles between the lights are a little larger than the upper one and they show considerable variation in the number of lobes in their foliations. At St Mary's, Barton on Humber *(Pl. 23b)* the lower circles of the south aisle windows are unfoliated and the upper circle trefoiled, while the sunk-spandrel window at Barrowden *(Pl. 9d)* has cinquefoils in its two lower circles and a quatrefoil in the upper one. In the east window of the north chapel at Stanion which has trefoiled lights *(Pl. 23c)*, the lower circles are quatrefoiled and the apex one trefoiled, and an aisle window at Howden, Yorks is similar except that all its three circles are quatrefoiled. It is not unusual that the central light of a three-light window is slightly taller than the outer lights, and this can also apply to three-light subarcuations of six-light windows and to the central light of a five-light window.

In windows of four or more lights, the principle of separation of the parts is maintained. Many four-light windows like those in the north aisle at Grantham *(Pl. 4c)* are essentially two adjacent two-light windows as subarcuations supporting a larger foliated circle in the apex. A five-light window at this church *(Pl. 23d)* introduces a single central lancet between the two-light subarcuations but otherwise follows the same idea, and similarly in six-light versions there and at Raunds *(Pl. 12a)*, the subarcuations are in effect three-light windows. In these typical examples the subarcuations are Non-Coincident with the window arch, and the rather disconcerting encroachment of their apices into the side spandrels tends to accentuate the visual independence of the top circle. Coincident subarcuations, as in the four-light south windows at Caythorpe *(Pl. 4b)*, avoid this quirk; however, idiosyncratic deviations from simple foliations in the circles of some of the Caythorpe windows suggest that they may be a little later.

## LATE GEOMETRIC

Towards the end of the thirteenth century and in the early years of the fourteenth, though before the introduction of the ogee curve in window tracery, there was a trend away from the strict discipline of the circle. Unencircled foliated figures and the pointed trefoil that from the later years of the thirteenth century became widely used in Late Geometric and later styles, (and which, to avoid confusion with normal round-lobed trefoils, will hereafter be referred to as a trilobe), were introduced followed by shapes based on the arcs of a circle, and each established a distinct Late Geometric sub-style.

## Unencircled Foliated Figures, Trilobes and Pointed Cruciform Quatrefoils

The three-light Non-Coincident east window at Trowse Newton, Norfolk *(Pl.29a)*, documented as dating from 1283-4, may be one of the earliest uses of unencircled figures in window tracery. Off-centre unencircled quatrefoils surmount the side lights, with a larger one, diagonally orientated, above the centre light. The side lights are trefoiled and the slightly taller central light cinquefoiled – also perhaps a pioneering occurrence of lights with a cinquefoiled arch.

A minor but important step towards the Late Geometric phase can be seen in a two-light window at Sheldwich, Kent *(Pl.24a)* in which the purity of strict geometric form is relinquished; the upper arc of the apex circle is modified to conform to the pointed profile of the enclosing window arch, thereby making an imperfect circle – one with a pointed top. In this instance the figure is cinquefoiled internally with a pointed top lobe, the others being rounded. Cusped spandrels in this window represent another small innovation relative to the Early Geometric norm. A similar imperfect circle in the apex of a window at Icklesham, Sussex *(Pl.24b)* encloses a trefoil, but the circle and the arches of the lights are visually outweighed by their heavy foliations and the trefoil, thereby reversing a proper balance.

Two-light windows at Bedingham *(Pl.24c)* and Oundle *(Pl.24d)* respectively with an unencircled trefoil and a quatrefoil above the lights show in the simplest form the complete abandonment of the apex circle.

As already seen in Chapter 4, a small unencircled trefoil surmounting a trefoiled sub-arch had appeared in lancet lights at Norton Disney *(Pl.10c)* and Yaxley *(Pl.17d)*, and this motif subsequently became a feature in the lights of two-light windows, either with rounded lobes as at Threekingham *(Pl.16a)* or as a trilobe in windows at Ufford *(Pl.16b)* and the north aisle at Barnack. In a comparable window at Soham, Cambs *(Pl.25a)* the sub-arches of the lights are cinquefoiled, and in a variation at North Creake, Norfolk *(Pl.25b)* and in almost identical windows at Spaldwick, Cambs an unencircled round-lobed trefoil occupies the apex space.

Two contemporary, alternating, three-light window patterns in the south aisle of Stoke Golding church, Leics provide telling illustrations of continuity and transition from the Early, through the Late Geometric, to the Intersecting style. Both have trefoiled lancet lights of equal heights with a trilobe in their apex, but in one *(Pl.25c)*, the window head has three encircled quatrefoils, one above two, in the typical Early Geometric manner, while in the other *(Pl.37b)*, the three lights intersect, with foliated intersection lights of curved diamond shape. The one with circles in the head makes an interesting comparison with stylistically similar two-light

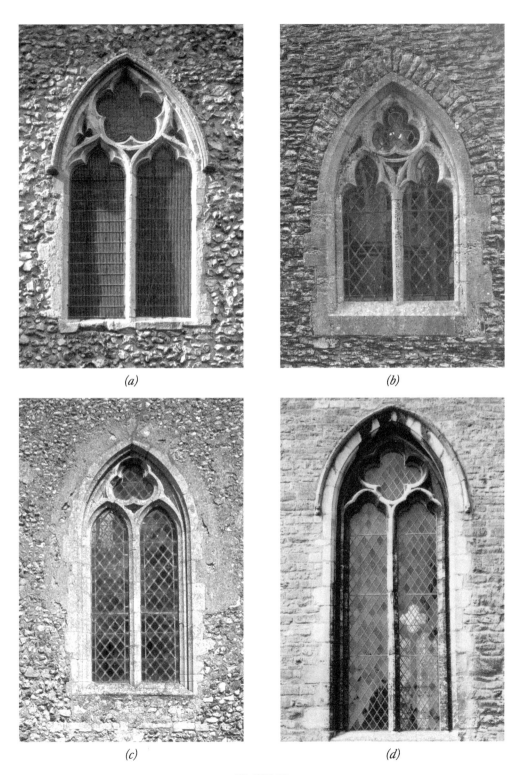

*(a)*  *(b)*

*(c)*  *(d)*

PLATE 24
*a. Sheldwich   b. Icklesham   c. Bedingham   d. Oundle*

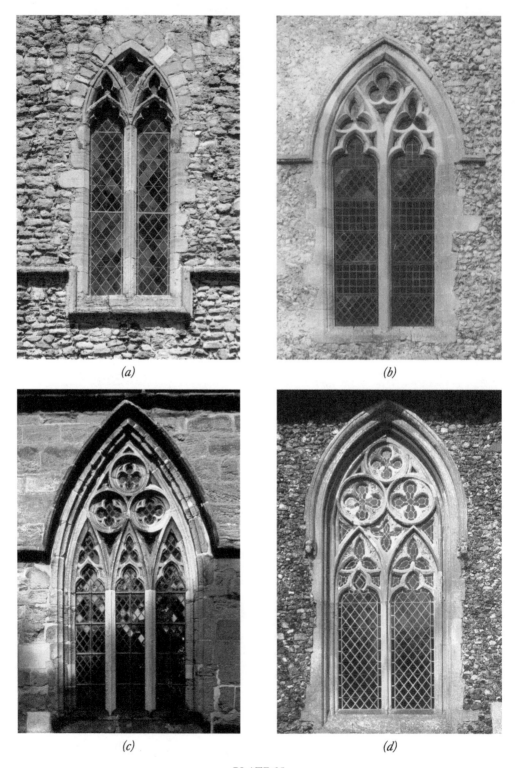

PLATE 25
a. Soham   b. North Creake   c. Stoke Golding   d. Rickinghall Inferior

windows at Rickinghall Inferior, Suffolk *(Pl.25d)* that also have trilobed lancet lights with three circles above.

Trilobes also feature in the heads of each light of a four-light subarcuated window of the ruined refectory of Little Walsingham Priory, Norfolk *(Col.Pl.I)* although the quatrefoil in its apex and the smaller ones in the subarcuations are still encircled.

The east window of the north chapel at Oundle *(Pl.26a)* is interesting both for its unusual visual structure and its combination of several Early and Late Geometric motifs. It is essentially a three-light Non-Coincident subarcuation beneath a large trilobe decorated with ballflower. Since its apex is formed by the bottom cusp of the trilobe, its arch acquires a slight ogee shape. In the centre compartment a circle containing smaller ones rests on a shorter middle light. The tracery of the side lights comprises a trilobe over a trefoil sub-arch.

In the head of a window at Orston, Notts *(Pl.26b)*, an even larger trilobe than the one at Oundle could be of about the same date. Its pointed lobes have a clear affinity with those of the pointed cruciform quatrefoil in the apex of another window at the same church *(Pl.26c)*. This figure has the shape of a cross with tapering arms, usually with vertical and horizontal axes, and appears in plain and cusped versions in the nave west window at Howden *(Col.Pl.II)*, dateable to the early 1300s; it also occurs at Northborough *(Pl.26d)* and as Plate tracery at Carlby *(Pl.7c)*.

Diverging from typical Early Geometric forms, a lower middle light between Coincident side lights of a three-light window at Gaddesby *(Pl.27a)* supports a large circle that fills the widening apex of the centre compartment and encompasses a trefoil with blunt pointed lobes, and in the east window at Spaldwick *(Pl.27b)*, of similar skeletal configuration though with single-order tracery, the circle in its head contains three separate trefoils rather than a single figure or foliations. The five-light east window at Fishtoft *(Pl.27c)* with two Coincident subarcuations also has a large circle in the apex which encloses three pointed cruciform quatrefoils with a trilobe in the middle, and in each of its subarcuations a circle containing three small trilobes. Its motifs have stylistic affinity with the chancel east window of similar proportions at Market Harborough, Leics where three trilobes like those in the subarcuations at Fishtoft occupy its big centre circle, but its subarcuations are Non-Coincident with ogee lights and a vesica in their apices.

Coincident subarcuations of the fine four-light east window at Rippingale, Lincs *(Pl.27d)* are precise replicas of the two-light Non-Coincident windows of the south aisle in which a large unencircled trefoil figure occupies the apex above trefoiled lights; a similar trefoil, inverted, in the apex of the four-light window reflects those in the subarcuations. In a Non-Coincident three-light version of this theme at St Peter's, Barton on Humber *(Pl.28a)* an inverted trilobe fits harmoniously into the apex space between two large trefoils above

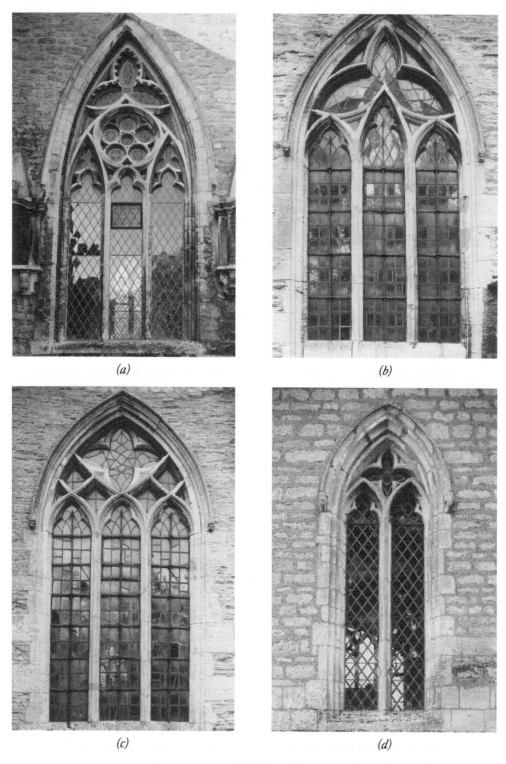

*(a)*

*(b)*

*(c)*

*(d)*

PLATE 26
*a. Oundle   b. and c. Orston   d. Northborough*

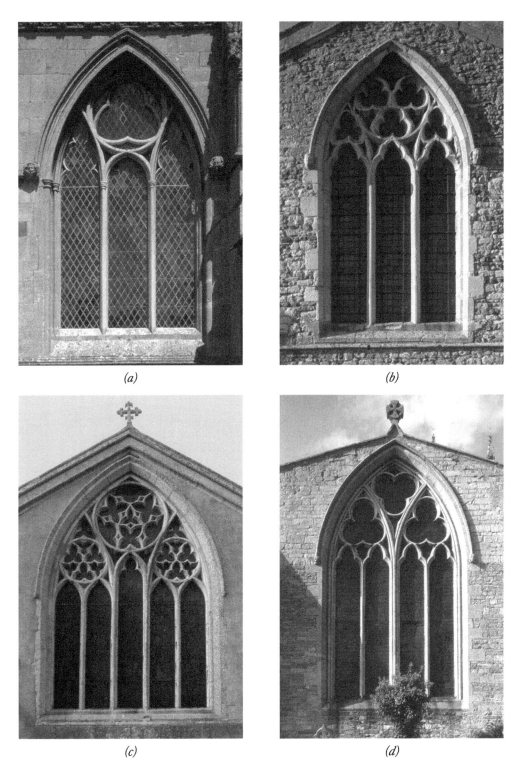

*(a)*          *(b)*

*(c)*          *(d)*

PLATE 27
*a. Gaddesby   b. Spaldwick   c. Fishtoft   d. Rippingale*

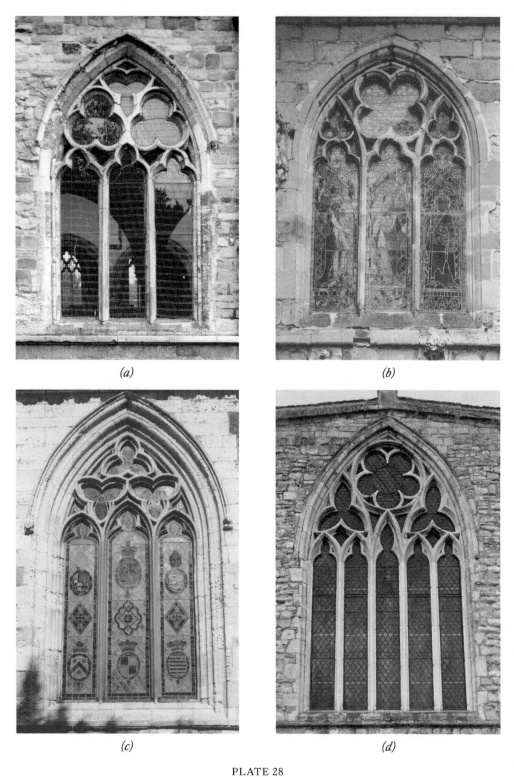

*(a)*

*(b)*

*(c)*

*(d)*

PLATE 28
*a. Barton on Humber, St Peter   b. Shifnal   c. Howden   d. Barton on Humber, St Mary*

the lights. A window at Shifnal, Shropshire *(Pl. 28b)* of similar visual structure to the Gaddesby window *(Pl. 27a)* also has a single figure in the head, an unencircled quatrefoil set diagonally, and its Coincident side lights have apex tracery similar to that of the Yaxley window *(Pl. 17d)* – a trefoil surmounting a trefoiled subarch. This window, though, is probably a little later since it occurs above a mature ogee arch in the lower part of a wall. Three unencircled trilobes form the tracery of alternating side windows of the aisles at Howden *(Pl. 28c)*, and larger versions occupy the apices of the two-light side subarcuations of the five-light east window at St Mary's, Barton on Humber *(Pl. 28d)* which makes an interesting comparison with the one at Fishtoft, having the same visual structure.

Later three-light windows at Heydour, Lincs *(Pl. 29b)* and Hedon, Yorks *(Pl. 29c)* are comparable to the Trowse Newton window *(Pl. 29a)* in that they use similar shapes, but the manner in which unencircled quatrefoils in their window heads link with each other and relate to the apices of their trefoiled lights represents a departure from the Geometric concept of individuality of features; without resort to ogee curves, they foreshadow the repetitive patterning of the Reticulated style.

## The Vesica

A vesica is an upright pointed oval figure formed by the intersection of two arcs struck from centres at the opposite ends of a common horizontal radius, each passing through the other's centre. In practice as a tracery motif, it was often internally foliated in the form of a quatrefoil with rounded side lobes and pointed ones at top and bottom, though the top lobe was also often rounded.

As has been seen in the window at Glapthorn *(Pl. 7d)*, the vesica made a thirteenth-century appearance in Plate tracery; its subsequent recurrence in Bar tracery as a principal motif established a distinct style that continued in the early fourteenth century and into the Curvilinear style, and the motif itself also developed into derivative shapes.

Supported by Non-Coincident lights, the tips of whose pointed arches encroach into the spandrels as in some Early Geometric windows, an unfoliated vesica occupies the apex in a two-light window at Coston, Leics *(Pl. 30a)*, and in an otherwise similar window at Melton Mowbray, the lights are trefoiled and the vesica foliated. It was not unusual for the lower arcs of a vesica in this position to adopt the curves of the arches of the lights on which it rests, imparting slight reversals of curvature and eliminating a small triangular piercing below. The resultant figure could thus become more tapered and pear-shaped than strictly vesical. Windows at Quidenham *(Pl. 38a)* and Carlton Scroop, Lincs *(Pl. 38b)* and many others elsewhere show this development.

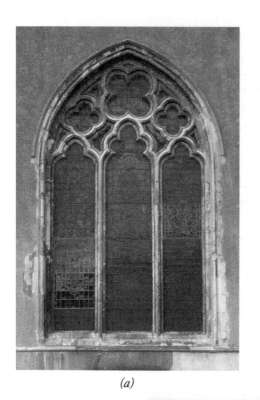

(a)

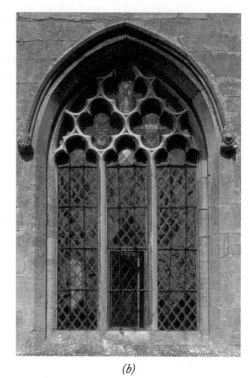

(b)

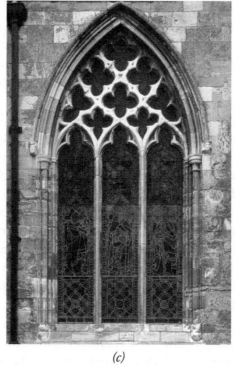

(c)

PLATE 29
*a. Trowse Newton   b. Heydour   c. Hedon*

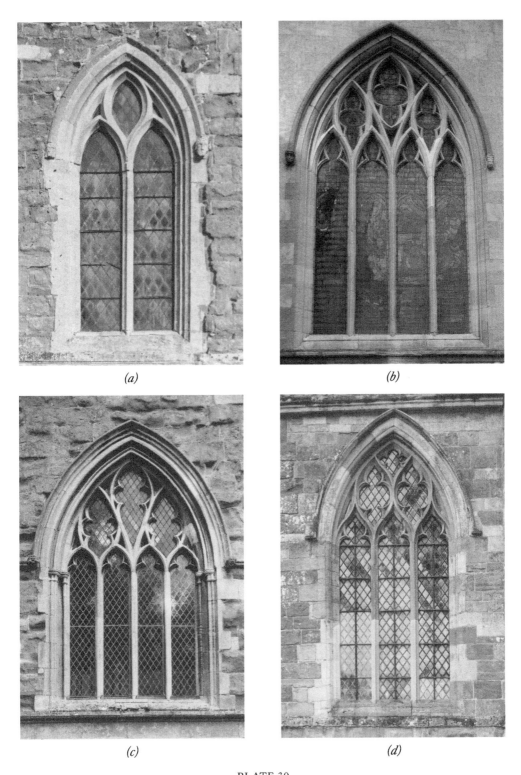

*(a)*

*(b)*

*(c)*

*(d)*

PLATE 30
*a. Coston   b. Melton Mowbray   c. Gaddesby   d. Misterton*

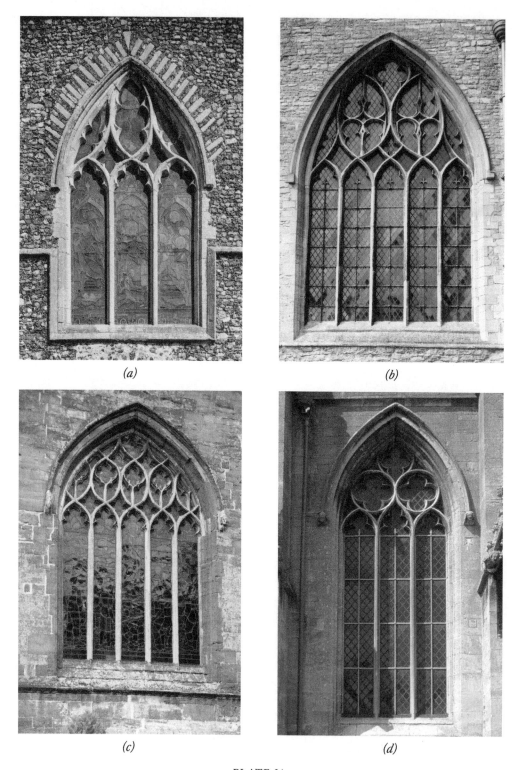

(a)

(b)

(c)

(d)

PLATE 31
*a. Felsham   b. Oundle   c. Kislingbury   d. Heckington*

Coincident subarcuations of a four-light window at Melton Mowbray *(Pl.30b)* replicate the two-light window there except that the tips of their lights do not penetrate the spandrels and their elements are narrower; the apex space between them is occupied by a true vesica which leaves a small triangular piercing below. By contrast, in an otherwise similar four-light Coincident window at Gaddesby *(Pl.30c)*, the lower ends of the central vesica's arcs are omitted, converting it into a narrow Curvilinear pear shape.

Below an obtuse window arch, a four-light Non-Coincident window at North Luffenham, Rutland has a vesica above the two central lights and smaller, narrower ones above the side lights, and at Higham Ferrers, Northants a later four-light subarcuated window has a vesica in the head of each of its subarcuations above Non-Coincident ogee lights; a cinquefoiled circle in the apex illustrates the continuity of tracery features from earlier times.

The vesicas in the Curvilinear three-light windows at Misterton, Leics *(Pl. 30d)* and in one at Hedon show how small a variation to their proportions is needed to transform the arches of pointed window lights as at Melton Mowbray *(Pl. 30b)* or Gaddesby *(Pl.30c)* into ogee shape.

In a three-light ogee intersecting window in the tower at Felsham, Suffolk *(Pl.31a)*, the apex figure is a tall vesica formed by the upwards extension with reversed curvature of the arcs of the middle light's arch. Vesicas are also the main elements of the tracery above intersecting ogee subarcuations in five-light windows at Oundle *(Pl.31b)* and Kislingbury *(Pl.31c)* – two large ones in the former and three smaller ones in the latter.

In larger windows of the fourteenth century a true or tapered vesica became the focal feature of many designs, forming an element of the window's visual structure as well as a defining feature of its style. A fine example containing five subordinate figures can be seen in a four-light window at Sleaford *(Pl.5b)*.

In the above examples, the vesica is the principal motif of the tracery, but there are countless instances in which it is included as a less predominant feature, often as an apex figure. Typical are three similar windows at Billingborough, Melton Mowbray and in the east wall of the south transept at Heckington *(Pl.31d)*, probably all dating from the first quarter of the fourteenth century; their three pointed lights, of which the centre one is a little taller with a slight ogee at its apex, support two circles which in turn support an apex vesica. Their differences lie in the circles: at Billingborough they are clear, at Heckington quatrefoiled and at Melton curved bifoils form mouchette wheels.

This kind of application was commonly adopted at the end of the thirteenth century and, in parallel with the true vesica, continued in use extensively throughout the Curvilinear and Perpendicular periods of the fourteenth and fifteenth as the apex figure in windows of any size, usually with a soufflet quatrefoil within.

(a)

(b)

(c)

(d)

PLATE 32
*a. Aldwinkle, St Peter   b. Blundeston   c. Hingham   d. Attleborough*

In many two-light windows the proportions of the apex vesica were varied to accommodate alternative internal motifs. These include Petal tracery as at Bozeat, Northants *(Pl. 49a)* and elsewhere, foliated crescent figures embracing a plain or ogee vesica as at Aldwinkle, St Peter, Northants *(Pl. 32a)* or Blundeston *(Pl. 32b)*, mouchettes as at Hingham, Norfolk *(Pl. 32c)*, or two small vesicas interleaved with flexuous soufflets as at Attleborough, Norfolk *(Pl. 32d)*. This latter device occurs within the apex vesicas of the Coincident subarcuations of the four-light east window at Fordham, Cambs and similarly in those of a five-light window at Soham *(Pl. 57b)*. The same combination is also adopted in the Non-Coincident two-light subarcuations of the large five-light window under a three-centred arch in the south transept at Northborough *(Col. Pl. III)* which has an ogee centre light taller than the pointed lights within its subarcuations.

In a six-light window with Intersecting ogee subarcuations at Sleaford, and in a similar but not identical one at Newark, Notts a large vesica acts as a focal point in their apex, and at Heckington and Hawton, Notts seven-light windows of comparable design achieve a similar visual effect.

### Spherical Triangles and Squares

The so-called spherical triangle is an equilateral triangle whose sides are arcs of circles struck from the angles of the triangle. As the apex element of a two-light window's tracery, the extremities of its base rest on the apices of the arches of the lights below *(Pl. 12c)*, those arches encompassing notional

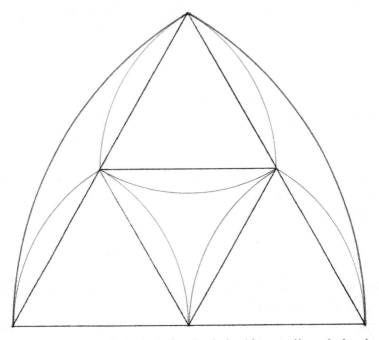

*Fig3. The geometry of spherical triangles derived from equilateral triangles.*

triangles of the same size. These three triangles themselves form a larger equilateral triangle. This configuration is illustrated diagrammatically in Fig.3. No firm date has been established for the earliest spherical triangle but it was probably introduced before the end of the thirteenth century and became a feature of the first quarter of the fourteenth.

A two-light Non-Coincident window at Stanion *(Pl.39a)* shows an early appearance of the spherical triangle; probably of the late thirteenth century, it is of typical Early Geometric style except that instead of the customary trefoil or quatrefoil in its top circle, there are three small spherical triangles containing trilobes in the same pattern as in a window at Barnwell, Northants *(Pl.39c)*. In a four-light window at Sudborough *(Pl.33a)* of perhaps about the same date as the Stanion window, two Non-Coincident subarcuations support a large spherical triangle in the apex that contains three smaller trilobed ones. The subarcuations have Coincident lights each with a trilobe above a trefoil sub-arch (the motif of the Ufford window lights *(Pl.16b)* which was often adopted in later styles) and a quatrefoil in the apex.

Two-light windows of similar configuration to the one at Rockland St Peter *(Pl.12c)* are quite common, although more typically the single spherical triangle in the head is trefoiled and subordinate to the window stonework. That creates a better balance between the dominant and the lesser elements of the composition as in a three-light window at Quarrington, Lincs *(Pl.33b)* which has three spherical triangles; two rest on the apices of the lights below and the third rests on the apices of the two lower triangles.

Typically the lights are Non-Coincident and of equal size, and a window with an equilateral arch can accommodate three triangles in its tracery, but three-light windows of the north aisle at Great Hale have space for only two triangles because the window arches are more obtuse *(Pl.33c)*. The four-light east window of this aisle also incorporates two spherical triangles but an ogee element in its more intricate pattern suggests a relatively later date for these Great Hale windows.

In a three-light variation at Rothwell, Northants the lower spherical triangles are larger and slightly tilted inwards with a smaller one on top, and at Morton, Lincs *(Pl.33d)* a taller centre light causes the two lower triangles to be placed at unusual angles. The spherical triangles at both these are hexafoiled.

The continuation of the spherical triangle motif well into the Curvilinear period is demonstrated in a three-light window at Hingham, probably of the second quarter of the fourteenth century, in which two such triangles surmounting the lights are each filled with six curvilinear mouchette shapes, echoing similar shapes in the heads of the lights.

The spherical square, a figure analogous to the spherical triangle, is formed by four arcs of a circle and is occasionally found in window tracery, but

(a)

(b)

(c)

(d)

PLATE 33
*a. Sudborough   b. Quarrington   c. Great Hale   d. Morton*

PLATE 34
*a. Gosberton   b. Bingham   c. Shifnal   d. Northborough*

as is shown in three-light chancel windows at Market Harborough, the shape is unsympathetic to the lines of pointed arches and probably explains why there are not many instances of its use. It is prominent though, in the apex of the nave west window at Howden *(Col.Pl II)*, and in a similar position in a smaller three-light window at Billingborough *(Pl.35d)* the curves of the arch of the central light reverse their curvature to become the lower arcs of the square.

Even less compatible with the spirit of Gothic architecture is a window in the north aisle of Barkby church, Leics which nevertheless might be medieval. It has three equal pointed lights above which a transom spans the full width of the window arch and forms the bottom members of two straight-sided squares side by side, quatrefoiled internally; the top sides of the squares form another transom which seems to have curtailed a small foliated figure in the apex.

## Stepped Archlets

If the lower arcs of spherical triangles such as those in the window at Quarrington *(Pl.33b)* were to be removed, the resulting figures would become small archlets springing from the apices of the lights or the lower triangles. This concept is realised at its simplest in an uncusped two-light window at Gosberton, Lincs *(Pl.34a)* and in a three-light version at Coston where two archlets spring from the apices of the lights below and in turn support one above. In three-light windows at Bingham, Notts *(Pl.34b)* the archlets are trefoiled and similarly in one at the west end of the north aisle at Hoby, Leics and one of this type at North Leverton, Notts. The latter is apparently contemporary with a window in the same wall that has Intersecting tracery.

The tour de force in this style is the five-light east window at Shifnal *(Pl.34c)* in which archlets in stepped tiers of four, three, two and one, each resting on the apices of those below, form a rhythmic pattern of reticulation. This pattern though, is quite distinct from the phase of the Curvilinear style known as Reticulated which it preceded.

Variations of the subordinate tracery within archlets are found. In the three-light ogee subarcuations of the six-light east window of the south aisle at Chipping Norton, Oxon *(Col.Pl.VII)*, instead of having simple cusped foliations as at Bingham or Shifnal, the archlets that spring from the apices of the lights enclose a trilobe above a dagger, and in three-light windows at Northborough *(Pl.34d)* the archlets contain two small mouchettes with a quatrefoil above. The Northborough windows have segmental arches with shallow Drop tracery, limiting the space above the lights for only two archlets.

From these instances of Stepped Archlet tracery, the style is easily understood as a direct development from spherical triangles.

## Kentish Tracery

Also known as split cusp tracery, Kentish tracery is characterised by having the cusps between the lobes of a foliated figure split into two barbs, often with straight spines extending back from the cusps. As a motif of window tracery, the style originated in the windows of the chancel at Chartham that was in course of building during the last decade of the thirteenth century. The unique four-light east window there *(Col.Pl.IV)* has two Coincident subarcuations whose tracery, and that in the apex between them, consists of diagonal cruciform quatrefoils with foliated lobes separated by split cusps; behind these straight or curved spines link them back to the mullions or to the window arch. The subarcuations of this window are exact replicas of the two-light side windows of the chancel *(Pl.35a)* except that the lights of the latter are trefoiled whereas those in the east window are cinquefoiled.

Other Kent examples include windows at Bobbing *(Pl.35b)*, Ulcombe and Cliffe. The two-light Non-Coincident Bobbing window has trefoiled lights supporting an inverted Kentish trefoil whose two curved lower spines continue the curves of the outer lights' arches. A three-light Coincident window at Ulcombe has Intersecting tracery with trilobes in its ogee-headed lights, and incorporates in the intersections three Kentish quatrefoils with spines. The Kentish motif occurs as a quatrefoil within a pointed-tipped circle in the apex of a window at Cliffe whose two lights have ogee arches and support other Curvilinear figures. The ogee elements of the Ulcombe and Cliffe windows indicate a later date than Chartham.

Split cusp tracery was not restricted to Kent and appears to have spread rapidly to other parts of England; it reached Kirkham Priory in Yorkshire early in the fourteenth century where the two-light windows of the gatehouse have a split cusp trefoil within a spherical triangle in the apex, and instances found in Sussex, Norfolk, Leicestershire, Rutland and Lincolnshire are likely to be about the same date or not much later. At Winchelsea, Sussex a three-light window has split cusp trefoils within spherical triangles *(Pl.35c)*. Hellington, Norfolk has a rather heavier version of the Bobbing window with single-order tracery on the wall plane, but other Norfolk examples at Norton Subcourse and Harpley may be a little later than the first quarter of the fourteenth century. Split cusp trefoils occur in the chancel east window at Stoke Golding and a four-light window in the chancel at North Luffenham has one within a large spherical triangle in the apex; this window appears alongside one with ogee intersected tracery and so may also be a little later. The spherical square in the apex of the three-light south aisle windows at Billingborough *(Pl.35d)* referred to above contains an unusual figure having four small foliations and wide split cusps between, with spines that extend back to the corners of the square.

*(a)*

*(b)*

*(c)*

*(d)*

PLATE 35
*a. Chartham   b. Bobbing   c. Winchelsea   d. Billingborough*

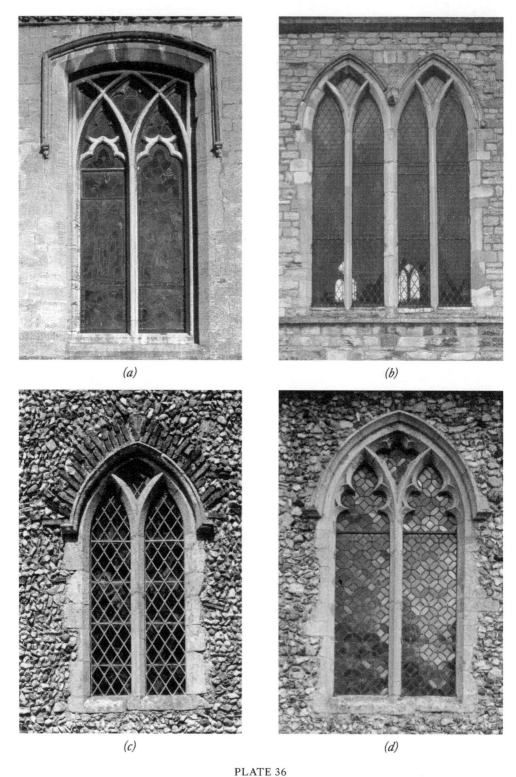

(a)

(b)

(c)

(d)

PLATE 36
*a. Barnack   b. Barton on Humber, St Mary   c. Hemblington   d. Billingford*

## Intersecting and Y-Tracery

There appears to be some ambiguity between different authorities as to whether Intersecting tracery should be regarded as of the Early English style or the Decorated, or indeed whether it is a phase of the Geometric style. Pevsner often dates it as circa 1300 although earlier instances are known and it persisted well into the fourteenth century, frequently recurring even later.

Probably originating a little before the emergence of the ogee arch in tracery and based on the geometry of a circle, Intersecting tracery is a Coincident configuration formed by the branching of each mullion of a window into arcs with the same radius as the window arch but struck from centres at different positions on the springing line; the arcs meet the window arch and cross each other to describe a series of intersecting arches and subarcuations that, irrespective of the number of lights that they embrace, have equal emphasis and establish in the window head a network of curved diamond lights of varying proportions between the intersections. It is a versatile repetitive concept conformable to any number of lights; at its simplest, it is of a single order with no foliations and was very commonly used particularly in three-light form.

A two-light window beneath a pointed window arch does not of course have any intersections and the two-light version of the concept, known as Y-tracery, is simply a pair of Coincident lancets with a branching mullion between them and a curved diamond in the apex *(Pl.36c)*. The Y-tracery style is generally understood as applying more specifically to windows with equilateral arches with no figure in the curved diamond apex and no subordinate tracery in the lights. However, in windows with a shallow segmental arch, spandrel piercings are introduced at the window's shoulders, and where the inner curves of the lights' arches are continued through the spandrels to meet the segmental head of the opening, echoing the idea used in the Greatford window *(Pl.8c)*, the basic pattern of intersection manifests itself.

The east end of the south aisle at Barnack has windows of this kind *(Pl.36a)*, with subordinate tracery in its lights of the same Late Geometric pattern – an unencircled round-lobed trefoil above a trefoiled sublight – as in the lights of the pointed north aisle windows there; this is the pattern that was used in the lights of the window at Norton Disney *(Pl.10c)* with Sunk-spandrel tracery referred to in Chapter 3 as possibly predating the Intersected and Y-tracery phase.

An exceptional pairing of two Y-traceried units to form a four-light window occurs at St Mary's, Barton on Humber *(Pl.36b)* where instead of the four lights being unified by intersection, two couplets are set side by side

with a common mullion between, but each couplet has its own separate arch and hoodmould. Could this indicate a tentative intermediate link between Y-tracery and Intersecting?

Cusped Y-tracery follows the same structural pattern as plain Y-tracery but has simple foliations in the lights and apex. A fourteenth-century window at Hemblington, Norfolk *(Pl.36c)* and a cusped version at Billingford, Norfolk *(Pl.36d)* are typical among countless examples respectively of plain and cusped Y-tracery windows.

Three-light windows with Intersecting tracery are as universal as their two-light Y-tracery counterparts; typical are windows in the aisles at Great Gonerby, Lincs where plain *(Pl.37a)* and cusped versions occur in the same walls, and also plain and cusped Y-tracery windows. The Intersecting windows with trilobe tracery in the lights at Stoke Golding *(Pl.37b)* referred to earlier in this chapter and comparable Intersecting windows at Stanion, Glapthorn and elsewhere probably date from the late thirteenth century. It seems therefore that there may be no significant difference in the date of introduction between the plain, the foliated and the traceried versions of Intersecting and Y-tracery styles; all were probably in use by the beginning of the fourteenth century.

Three-light Intersecting windows in the aisles at Garboldisham, Norfolk with the same visual structure as those at Stoke Golding have tracery motifs that suggest a fourteenth-century date, though they are still without ogees. In each pointed light a raindrop figure containing a quatrefoil with three rounded lobes and a longer pointed top one rests on a cinquefoiled segmental sub-arch. This tracery pattern within the lights became very popular and was often used in the side lights of later multi-light windows, including in Perpendicular designs. The window also has a small quatrefoiled oculus in its apex intersection.

Other minor variations from the normal patterns of intersection appear in three-light windows at South Croxton, Leics; in one, only the lights are foliated, and in another the lights have inner, though not subordinate, pointed trefoiled sub-arches. These windows appear to be original elements of the same wall in which there is a two-light Early Geometric one, and so may be relatively early.

Three four-light windows at Grantham illustrate different degrees of embellishment of the standard Intersecting style: the south aisle has a straightforward plain one and one with foliated intersections and septafoil cusping in the lights, but above the west door, the surround and all the members of the unfoliated four-light window are profusely decorated with ballflower ornament *(Col.Pl.V)*.

Further elaborations of Intersecting tracery are seen in the fine five-light nave west window beneath its ballflower hoodmould at Melton Mowbray

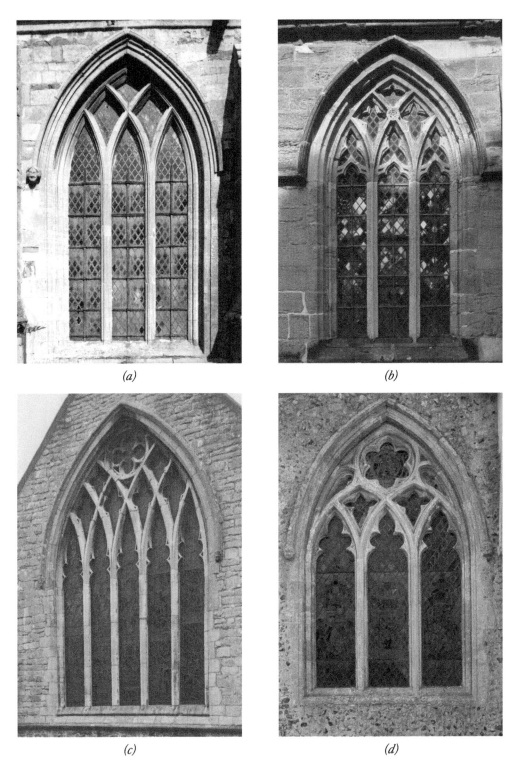

*(a)*

*(b)*

*(c)*

*(d)*

PLATE 37
*a. Great Gonerby   b. Stoke Golding   c. Bulwick   d. Merton*

*(Col.Pl.VI)*. Its lights have trefoiled sub-arches below trilobes of a similar pattern to those in the lights of the Ufford window *(Pl.16b)*; the upper tiers of intersecting lights are foliated in the normal way but each curved diamond of the lower tier contains a trefoil with two round lobes and a pointed top one, and these rest on a small 'dagger' device – an early appearance of a motif much used in later tracery.

Introduction of a figure in place of the topmost intersections of four- and five-light Intersecting windows was a development of the late thirteenth century and the early fourteenth. Visually it has the effect of creating two subarcuations. A five-light cusped window at Bulwick, Northants *(Pl.37c)*, probably one of the earlier ones, is effectively transformed by the encircled quatrefoil in its apex into two three-light intersecting subarcuations. The same effect is produced in a similar but more elaborately foliated window at Trumpington, Cambs where the apex quatrefoil is unencircled, the lights have trefoiled sub-arches and the curved diamond lights are variously foliated. In four-light windows of the same general pattern at Stoke Golding *(Pl.40b)* and Somerby, Leics *(Pl.40c)* the apex figure, displacing the upper arcs of the inner lights, eliminates any intersection and converts potentially intersecting lights into a pair of two-light subarcuations.

As a tracery style in which the visual structure is itself the defining element of the style, it is useful to differentiate between windows in which Intersecting tracery establishes the style and those of other styles in which intersection is part of their visual structure rather than their style. The windows described above that conform generally to the former category though, inevitably may embody features of other styles. Intersection as a feature of a window's visual structure as opposed to its style tends to be more usual in windows with an odd number of lights; examples include the three-light Perpendicular windows at Lowick, Northants *(Pl.65c)* and Raunds with intersecting subarcuations, the lofty five-light Curvilinear west window at Attleborough *(Pl.50c)* with three-light intersections, and five-light Perpendicular windows with three-light intersections at Empingham *(Pl.65d)* and Little Shelford, Cambs which are typical of many others elsewhere. The seven-light Perpendicular east window of the north chapel at Grantham *(Pl.64a)* has four-light intersecting subarcuations.

Except where a window's side lights or subarcuations have ogee arches, the visual framework of Intersecting styles is essentially Coincident with the window arch, but sometimes a Non-Coincident form of intersection is found in windows where non-ogee subarcuations with arches more obtuse than the window arch interlock. In the three-light east window of the south aisle at Merton *(Pl.37d)*, the pointed arches of two-light Non-Coincident intersecting subarcuations support an imperfect hexafoiled circle in the apex, and at Carbrooke, Norfolk the five-light east window has four such two-light

intersecting subarcuations; the apex circle there is quatrefoiled with trefoiled lobes and wide split cusps between and is flanked by smaller circles; otherwise its details are similar to the Merton window. These two churches are less than five miles apart.

In a three-light window at Raunds *(Pl. 46d)* and in a similar one at Ringstead, Non-Coincident two-light intersecting subarcuations have segmental arches, with Curvilinear motifs above. In certain convergent Curvilinear patterns (see Chapter 6, Asymmetric Subarcuations) an asymmetric intersection results from combining two lights of different heights within a subarcuation, as in windows at Hallaton *(Pl. 46b)*, Ufford and Lyddington, Rutland.

## CHAPTER 6
# Curvilinear Tracery

The defining ethos of Curvilinear styles flows from the double curvature of the ogee, a shape which increasingly became a feature of window tracery during the later stages of the Late Geometric phase. In contrast to the static non-directional elements of Geometric tracery, curvilinear styles introduce figures and spaces of sinuous shapes defined by curving lines that extend from the mullions and branch in different directions. The ogee form is not of itself a tracery style but it is an important constituent of Curvilinear and later styles. Just as pointed, trefoiled or cinquefoiled arches are not specific to one style, neither is the ogee arch.

There are alternative ideas as to how the ogee shape may have been introduced into window tracery. Was it an outcome of conscious innovative design or was its appearance involuntary? Alternative possibilities of the latter theory can be examined through steps of development in windows of the late thirteenth century or the early fourteenth, of which most are not precisely datable.

As was mentioned with respect to vesicas in Chapter 5, the lower end of a vesical figure occupying the apex of a two-light window will often deviate slightly from perfect geometrical symmetry vis-à-vis the top end by following the inner curves of the lights' arches, thereby introducing incipient ogee curvature in the lower sides of the figure. Three small steps in this interaction between the arches of the lights and the vesical figure can be traced. At Quidenham *(Pl.38a)*, the apices of trefoiled pointed lights penetrate into the spandrels in the manner of Early Geometric windows, but at Carlton Scroop *(Pl.38b)* or Muston *(Pl.9c)*, while the lights still have non-ogee pointed arches, their apices coincide with the points at which the reversal of curvature of the sides of the vesical figure occurs. At Ashwell, Rutland *(Pl.38c)*, the apices of

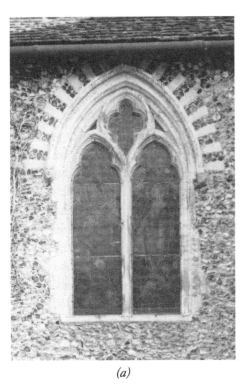

*(a)*

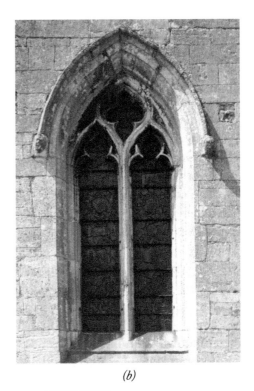

*(b)*

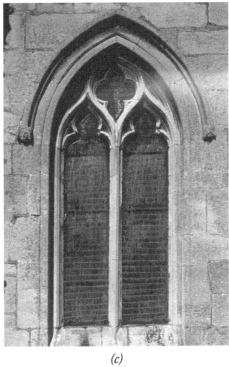

*(c)*

PLATE 38
*a. Quidenham   b. Carlton Scroop   c. Ashwell, Rutland*

the arches of the lights meet the apex vesica above the level at which the curvature of its sides reverses, causing the arches to follow the same curvature and acquire a clear ogee shape. Apart from that, any difference between the Ashwell design and the Carlton Scroop window is insignificant, and this suggests a distinct possibility that the ogee shape could have arisen simply as an accident of geometry rather than as a result of conscious design.

An alternative fortuitous origin may have been a development from the simple Geometric style of two-light windows in which the apex circle is an independent figure resting on un-deformed arches of pointed lights below, like one at Stanion *(Pl.39a)*. If however, the lower part of an apex circle's circumference encroaches on the arches of the lights, it deforms them and establishes reversed curves at their apices, and consequently ogee arches result. Whether at different places this just happened empirically or by conscious intent is likely to remain uncertain. At Bearstead, Kent *(Pl.39b)* and Icklesham windows of this design respectively have quatrefoiled and cinquefoiled apex circles; and in a comparable window at Barnwell *(Pl.39c)* the circle contains three spherical triangles, like those in the Stanion window. In a window at Burton Coggles *(Pl.56c)*, the circle contains three mouchettes, and in a three-light version embodying this kind of interaction between circle and arches, the two circles of a window at Winfarthing, Norfolk *(Pl.39d)*, which has a small vesica in its apex, are octofoiled with unusual round-tipped cusping. The arrangement in which the lower arcs of an apex figure create ogee curves below occurs on the grand scale in a six-light window at Chipping Norton *(Col.Pl.VII)*, said to have been moved from Bruern Abbey, Northants after its dissolution in 1535. Its tracery may be a little later than the two-light examples mentioned above but its principal motifs are still Late Geometric. In this instance, the lower arc of a large apex circle creates the reversed ogee curves of its two supporting three-light subarcuations.

The ogee arches on the Eleanor Cross at Hardingstone have already been mentioned as being perhaps the earliest datable occurrence of this motif in architecture, and its use there has been proposed as the likely source of the new feature in England; however, the question remains as to whether the method of its application on this monument is indicative of an innovative design feature or whether, like the above instances, it was the fortuitous outcome of its location relative to adjacent motifs. The situation in which the ogees occur is blind stone tracery in two-light pointed window patterns of Y-form on the lower stage of the octagonal monument *(Pl.40a)*; the head of each blank light is occupied by a trilobe, below which a flat ogee sub-arch precisely follows the curvatures of the lower two foils of the trilobe. This could suggest that these ogee sub-arches resulted from conforming to a profile established by the trilobes. It may be relevant that equivalent decoration on the lower stage of the hexagonal Eleanor Cross at Waltham Cross is also a

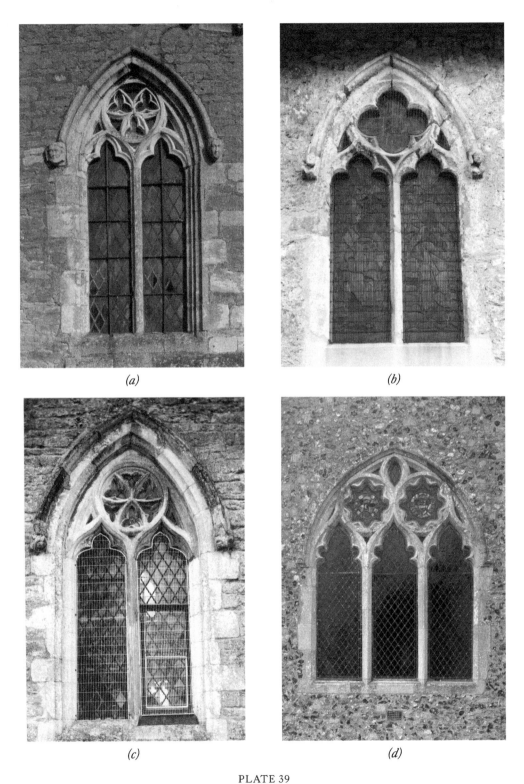

*(a)*

*(b)*

*(c)*

*(d)*

PLATE 39
*a. Stanion   b. Bearstead   c. Barnwell   d. Winfarthing*

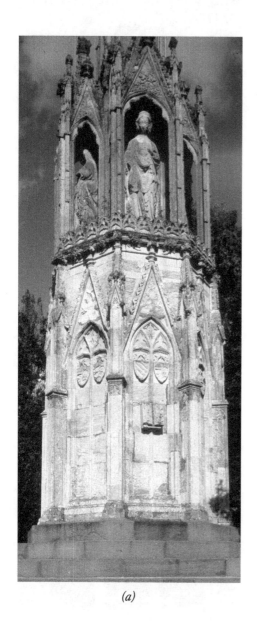

*(a)*

*(b)*

*(c)*

PLATE 40
*a. Eleanor Cross, Hardingstone   b. Stoke Golding   c. Somerby*

two-light blank window pattern but in Geometric style; facsimile window patterns used as decoration in the same manner on the two monuments could imply that both were based on window designs then existing.

For parallels with the Eleanor Cross blind tracery, it is instructive to examine actual window tracery of similar probable date in which a trilobe occupies the head of the lights. In the Intersecting south aisle south windows at Stoke Golding *(Pl.37b)*, dated by Pevsner as 1280-90, sub-arches below the trilobes are pointed trefoiled, and on close inspection the stonework of the trilobes' lower foils can clearly be seen to be resting on them, conforming with the Geometric concept of separate elements; similarly, in aisle side windows at Howden *(Pl.41b)* this separation is more distinct because the trilobes are subordinate relative to the trefoiled sub-arches of the lights. By contrast, in the four-light aisle west window at Stoke Golding *(Pl.40b)*, whose two-light subarcuations are comparable to the Ufford window *(Pl.16b)*, the cusp between the lower foils of the trilobes actually forms an ogee tip to the stonework of the top lobe of the trefoil light below, though the lobe itself does retain a pointed, non-ogee shape.

In the three-light Intersecting windows at Glapthorn and Stanion mentioned above, both dated by Pevsner as late thirteenth century, the apices of the lights' trefoils also merge with the stonework of the trilobes' lower foils, thereby acquiring a slight ogee at their tips. The lights of other windows of this period elsewhere are similarly treated, but the two-light subarcuations of the four-light window at Somerby *(Pl.40c)* are directly comparable to the blank tracery on the Eleanor Cross in having trilobes in the lights above flat ogee sub-arches, and no doubt other direct parallels can be found. It seems possible therefore that the emergence of the ogee in window tracery may not necessarily have been later than the dateable instance on the Eleanor Cross.

Notwithstanding that the period covering the last decade of the thirteenth century and the early years of the fourteenth was very fertile architecturally, these examples support the possibility that the initial introduction of the ogee into window tracery may have arisen fortuitously rather than as an architectural invention of an imaginative master mason. It was not long though before its potential for innovative design and diversity of new motifs was recognised and found expression in the Curvilinear styles of tracery. The three-light aisle west windows at Howden *(Pl.41a)*, probably of the first decade of the fourteenth century, show an innovative application of curvature in window tracery: not only do the side lights have an ogee sub-arch beneath a trilobe in the head, but while their outer curves follow the window arch, their inner curves have an ogee reversal to accommodate the circumference of a circle above the non-ogee centre light. This produces non-symmetrical side lights – a daring departure from earlier disciplines. Their trilobes make

*(a)*

*(b)*

*(c)*

*(d)*

PLATE 41
*a. and b. Howden   c. Ulcombe   d. Syderstone*

an interesting comparison with those in the alternating intersecting side windows of the aisles *(Pl. 41b)* in which, since the trilobes in the lights are subordinate to the round top lobes of the trefoiled sub-arches, their bottom cusps do not convert the sub-arches to ogee shape.

As an arch form in tracery the ogee arch was widely adopted in the first quarter of the fourteenth century and onwards and was used not only in the heads of individual window lights, trefoiled or cinquefoiled, but in groupings of lights forming subarcuations, particularly within larger windows. With upper and lower curves of similar or different radii struck from centres inside and outside the arch, an ogee arch is almost infinitely variable in proportions, varying from acute, like the lights of the three-light aisle windows at Great Hale *(Pls. 21b and c)*, to flat, as in the sub-arches of those windows.

Ogee arches of individual lights or as sub-arches within lights as in the Great Hale windows are common in windows of all sizes and styles from the early fourteenth century onwards, producing many variations. In a three-light window at Ulcombe *(Pl. 41c)* for instance, shorter side lights than the middle light and extension of their apices to the window arch create residual piercings and a tracery pattern markedly different from the Great Hale windows.

Two-light ogee subarcuations, often associated with intersection, occur in the three-light tower window at Felsham *(Pl. 31a)* and unsurprisingly in ogee Intersecting windows at many churches; they often also create the subdivisions of four-light windows as in Holbeach chancel, Lincs *(Pl. 48c)* or at Syderstone, Norfolk *(Pl. 41d)* and in some with five lights. In the larger windows ogee subarcuations tend to be elements of the window's visual structure rather than its tracery style.

With the advent of the Curvilinear tracery styles, motifs of new shapes emerged; prominent among these were the following:

> *Dagger*, a symmetrical cusped two-lobed shape with a round or pointed head and a longer pointed tail.
>
> *Mouchette*, curved versions of the dagger motif.
>
> *Soufflet*, a quatrefoil with rounded side lobes and pointed ones at top and bottom. There are common variants in which the top lobe is also rounded – a *Dagger Soufflet*.
>
> *Vesical Soufflet*, a vesical shape containing a soufflet form as subordinate foliation, and versions of this in which the pointed lobe is curved.
>
> Elongated adaptations of the soufflet, straight or curved.
>
> *Pointed Bifoil*, an elongated bifoil, pointed at both ends, often double curved.

*Falchion*, strictly, a curved-edge sword. Used as a general term for curved mouchette and soufflet shapes. Usually larger, curved or ear-shaped, and foliated within, often with prolific multi-cusping.

*Ogee Vesica*, a widened vesica with its upper and lower ends of ogee shape, usually foliated internally. As the repetitive feature of the Reticulated tracery style, it is also known as a reticulation unit.

*Pear Shape*, a figure of this shape, usually rounded or semi-vesical at the top and tapering with or without ogee curvature, to a point at the lower end.

*Raindrop Dagger*, a figure with a rounded lower end, tapering to a point at the top, usually foliated with an inverted soufflet or variant internally. Often used in the apex of a light above a sub-arch.

Vesical shapes were also used in other than their conventional vertical alignment, lying horizontally, diagonally or in radial patterns, and they were often multi-cusped internally. Residual piercings of varied shapes occur, such as foliated triangles of different proportions with round or pointed lobes or both, and the concave square, a square with concave sides set diagonally, became a significant element of windows with intersecting ogee subarcuations, as in Plates 4d, 31a and b, 42, 48b and 57c.

Many large windows contain tracery of more than one Curvilinear style, or Curvilinear motifs in association with Geometric or Perpendicular features. In the former circumstances, such windows are probably best considered simply as Curvilinear, and in the latter, they may more easily be differentiated by particular characteristics of their visual framework rather than from tracery style.

## OGEE INTERSECTING TRACERY

This format is another in which the window's skeletal framework is itself a defining feature of the style's essential character, a character arising from the grouping of two, three or more lights within intersecting ogee subarcuations. Surprisingly though, in most windows of this style the individual lights themselves, usually trefoiled or cinquefoiled, have non-ogee arches. Although superficially analogous to normal Intersecting tracery, there is a significant difference between the two; in the normal Intersecting tracery the arches of the lights and subarcuations are Coincident, whereas in the Ogee version they are Non-Coincident because their curvatures inevitably deviate from that of the window arch.

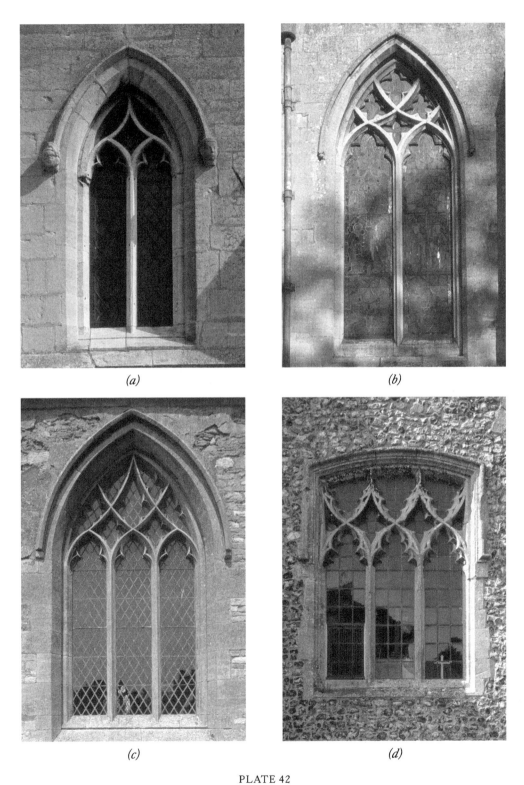

*(a)*

*(b)*

*(c)*

*(d)*

PLATE 42
*a. Claypole   b. Barnack   c. Threekingham   d. South Creake*

As with Y-tracery, the arches of a pointed window of only two lights cannot have ogee intersection, but a visual equivalent of Y-tracery can be established by the pairing of two Non-Coincident pointed lights under a single ogee arch, the tip of which extends up to the window arch apex. This pattern was often used and can be seen in the two-light aisle west windows at Claypole, Lincs *(Pl. 42a)*. A different ogee intersecting effect is achieved in a two-light window in the chancel at Barnack *(Pl. 42b)* where, above their apices, the curvatures of the lights' arches are reversed and extended to meet the window arch.

At Helpston, in a window with a segmental arch, the pointed lights are unified under a shared ogee head as at Claypole but above their apices the inner curves of their arches are extended with reversed curvature to meet the window arch at its springing points. The resulting pattern is such that each half of the window could be read as half of a two-light ogee arch.

Because of the limited scope for intersections in two-light windows, the distinctive aspects of Ogee Intersecting tracery can only be fully realised in windows of three or more lights, and though not as common as plain Intersecting, three-light versions are many and varied. The normal design comprises three lights forming two two-light intersecting subarcuations whose outer curvatures extend upwards to meet at the window apex, thereby creating a three-light subarcuation – another difference from the Intersecting style where the window apex is occupied by a pointed diamond or a geometrical figure.

At Claypole, the three-light aisle windows with trefoiled non-ogee lights and ogee intersections without foliations above make the ideal complement to the three-light plain Intersecting clerestory windows *(Col. Pl. VIII)*. The same type in the south aisle at Threekingham *(Pl. 42c)* has foliations in the intersection lights, and otherwise similar windows at Clipsham and Ashby Folville, Leics have additional ornament provided by ballflower around the window frame.

One of the three-light south aisle windows at Threekingham has a straight head, but otherwise its tracery is analogous to the pointed ones; with smaller radii to their upper curves, the apices of its two intersecting subarcuations ascend to the windowhead and create three inversions of the arch heads of the lights below them. A window at South Creake *(Pl. 42d)* is similar though under a shallow segmental arch; it has more elaborate foliations in all its lights.

The four-light south aisle east window at Great Hale *(Pl. 4d)* comprises three two-light intersecting ogee subarcuations, two side by side that do not intersect but their central mullions continue upwards, meeting at the window apex to form the ogee arch of a third central two-light intersecting subarcuation. The four lights are pointed with, in their heads, a trilobe above a flat ogee sub-arch, and unusually for ogee subarcuations, the lower curvature of their outer lights is almost coincident with the window arch.

As with plain Intersecting tracery, ogee intersections in larger windows,

particularly those of Curvilinear styles, were more significant as elements of their visual structure than of their tracery style.

## RETICULATED TRACERY

A significant new motif arising from the introduction of the ogee curve was the ogee vesica whose evolution can be followed in the apex features of Non-Coincident two-light windows. From the simple Geometric window with a foliated circle in the apex, it was but a minor step for its upper circumference to adopt the pointed profile of the enclosing window arch, as in the window at Sheldwich *(Pl.24a)*. Examination of windows with a circle in the apex, Barnwell *(Pl.39c)* for example, will show how little of the circle's top circumference is lost in this change. The next stage was the omission of the lower part of the circle, as in the windows at Quidenham *(Pl.38a)* and Carlton Scroop *(Pl.38b)* referred to above, and then, with ogee lights as at Ashwell, Rutland *(Pl.38c)*, the lower end of the apex figure acquires the ogee shape. Finally, the figure drops a little way below the window apex allowing its upper part fully to reflect the ogee shapes of the lower part, thereby creating a symmetrical figure. A two-light window at Ufford *(Pl.43a)* is typical, with countless others of similar design though they often differ in minor detail.

Motifs of this ogee vesica shape are important elements of many curvilinear styles, especially the Reticulated style in which its use to create a repetitive pattern gives the style its netlike appearance and its name. Two-light windows with only a single reticulation unit in the apex like the Ufford one cannot strictly be considered reticulate, but they do nevertheless represent the two-light version of the style.

Reticulated windows are commonly three, four and five lights wide, and where they have a normal pointed arch, those with three lights like at Nassington and many others elsewhere have two tiers of reticulations; those of four lights like the nave west window at Swaton *(Col.Pl.X)* have three tiers, and five-light windows as at Norton Subcourse *(Pl.43b)*, four tiers. Because its overall pattern is created by units of ogee shape, Reticulated tracery is inevitably Non-Coincident, leaving spandrel spaces at the edges occupied by partial reticulation units curtailed by the window arch. The lights of these window patterns almost invariably have ogee arches and the shape of the reticulation unit is such that it rests naturally in the valleys between them and in the similarly shaped spaces between adjacent units.

Some windows of this style are ogee-shaped, as at Deene, Northants and Harlestone *(Pl.3b)*, but their tracery varies very little if at all from the normal because the windows' ogee curves are near the apex and have only a slight reversal. At Finedon, where there are three- and five-light windows, not only are they of ogee shape, but their reticulations are unfoliated *(Pl.43c)*.

Another variation in window shape is found at Over, Cambs where

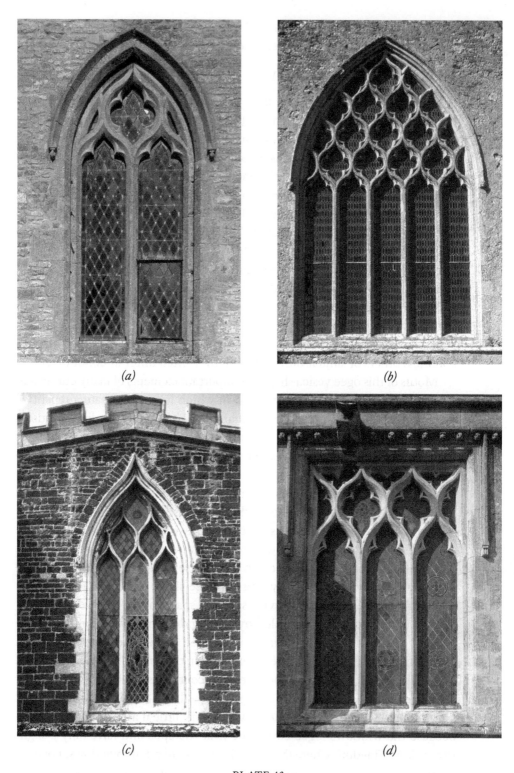

PLATE 43
*a. Ufford   b. Norton Subcourse   c. Finedon   d. Clipsham*

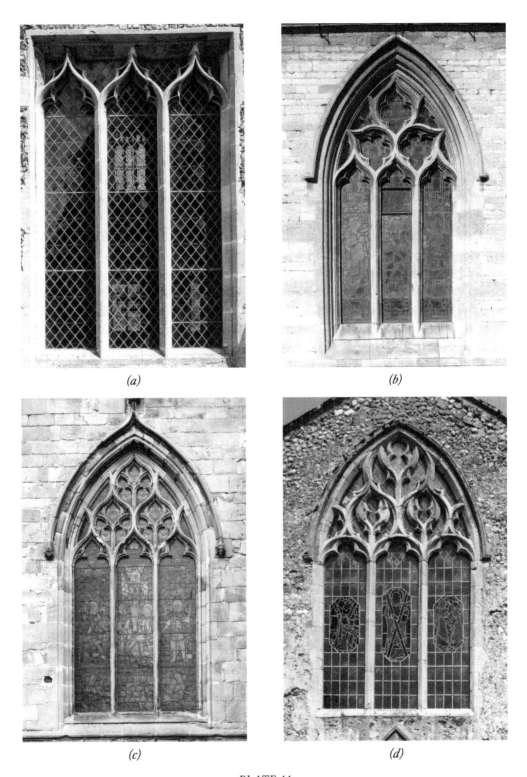

*(a)*          *(b)*

*(c)*          *(d)*

PLATE 44
*a. North Elmham   b. Boothby Pagnell   c. Shifnal   d. Great Ryburgh*

four-light reticulated windows have pointed segmental arches, resulting in a lower apex with space for only two tiers of reticulation, and instead of the usual incomplete units to fill the side spandrel spaces these windows have delightful curly mouchettes.

Reticulated windows with a straight head usually have a single tier of reticulation units in their tracery, as in a representative three-light example at Clipsham *(Pl. 43d)*. A window at North Elmham, Norfolk, though *(Pl. 44a)*, is typical of many straight-headed two- and three-light windows of this style in having only partial reticulations above the lights, as if the ogee vesica figures of the tracery were cut off halfway up. In these cases, the apices of the lights reach to the window head.

The Reticulated style is so widely found as to have come to be regarded as representative of the Decorated period, and several minor variations have evolved. Most common in three-light windows is the elimination of the ogee curves at the top of the apex unit to merge it with the window arch as in the window at Great Ryburgh *(Pl. 44d)*. A five-light window at Yaxley and a two-light ogee one at Earls Barton, Northants show a variation in which the reticulation units are elongated, giving them narrower proportions than usual.

There are several variants in which the reticulations of three-light windows depart to a greater or lesser extent from the standard shape. At Ashby Folville, little triangular spurs project from their sides to occupy the places in the side spandrels normally taken by partial units, and at Boothby Pagnell *(Pl. 44b)* and Long Bennington, Lincs the shapes of the reticulation units themselves are changed slightly by sprouting outwards-pointing 'ears'; in a tower window at Heckington units of the Boothby Pagnell shape are trefoiled within rather than having the normal four foliations. Another window at Long Bennington has a curious, rather jarring, variation in which a transom bisects the reticulations and in one of the windows at Langham the apex reticulation receives the same treatment.

At Hallaton and Asfordby, Leics mouchettes are introduced into the spandrel spaces, and at the latter the upper reticulation unit is divided by a pair of subordinate mouchettes and its top tip displaced by a small quatrefoiled vesica eyelet. Inclusion of subordinate motifs within reticulation units is not uncommon and is a feature of a window at Shifnal *(Pl. 44c)* and others in a group of churches in Norfolk that includes Beeston and Great Walsingham. The reticulation units of the Norfolk windows of this kind contain a vesical soufflet supported by pairs of mouchettes or embraced by elongated curved soufflets, and in certain three-light windows at Great Walsingham and Tunstead, the apex reticulation unit becomes a larger vesical shape containing four soufflet or mouchette figures. Curved bifoils in the reticulation units of the three-light south transept window at Great Ryburgh *(Pl. 44d)* enclose other shapes, and perhaps foreshadow the Flamboyant style.

## FALCHION STYLE

The term Falchion is adopted here as a style name being descriptive of the shape prevalent in Curvilinear windows in which the dominant elements are irregular asymmetrical piercings of raindrop or pear shape, usually curved with one end rounded and the other pointed or both pointed, and internally cusped with any number of subordinate foliations. Figures of this kind are often visually directional and can impart a converging or diverging sense of movement with upwards or downwards emphasis. The style is most recognisable in two-light and three-light windows and within subarcuations of larger ones but its motifs also appear in larger tracery patterns.

A transition from the Reticulated to the Falchion style is evident in certain three-light windows. In these windows, tracery figures above the arches of the lights are reticulation units but they differ from the normal pattern in that their upper ogee tip is replaced by a curve; above them, a pair of falchion shapes support the vesical apex figure. These intermediate motifs in a window of this type at Grafton Underwood are converging mouchettes, at Kibworth, Leics *(Pl. 45a)* divergent mouchettes, and at Gaddesby multifoiled falchions. In a four-light version of this theme at Hallaton, the central reticulation unit of three retains its ogee tip and the falchions above are elongated convergent mouchettes.

The simplest form of Falchion style is the two-light window in which the lights support a pair of upwardly oriented divergent mouchettes or soufflets, usually with a vesical figure or an unencircled quatrefoil in the apex. The lights may be pointed or ogee, trefoiled or cinquefoiled, and though the window components are few, they can make various combinations: a window at Somerby, Leics *(Pl. 45b)* for instance has trefoil lights and mouchettes, and a comparable one at Little Massingham, Norfolk has ogee cinquefoil lights with soufflets.

In convergent two-light versions, also normally with upward orientation, the central space between the lights and the mouchettes becomes a small concave square which may or may not be foliated, and the apex figure may be a shallow curved diamond as in a window at Sustead, Norfolk with cinquefoiled lights *(Pl. 45c)* or a small quatrefoiled eyelet as in the divergent types.

These two-light window patterns, particularly the divergent version, are often adopted in subarcuations of larger windows under pointed or ogee arches. The divergent pattern with a vesical soufflet in the apex above a pair of mouchettes or similar figures is common in this role, and for convenience will be referred to as a mouchette subarcuation. They occur coincident with the window arch in a four-light window at Gaddesby *(Pl. 45d)* for example, and non-coincidentally in several at Sleaford. Coincident mouchette

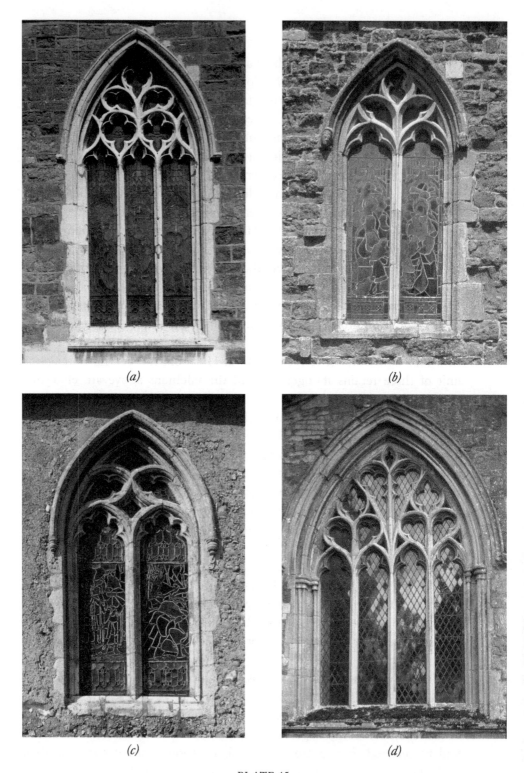

(a)

(b)

(c)

(d)

PLATE 45
*a. Kibworth   b. Somerby   c. Sustead   d. Gaddesby*

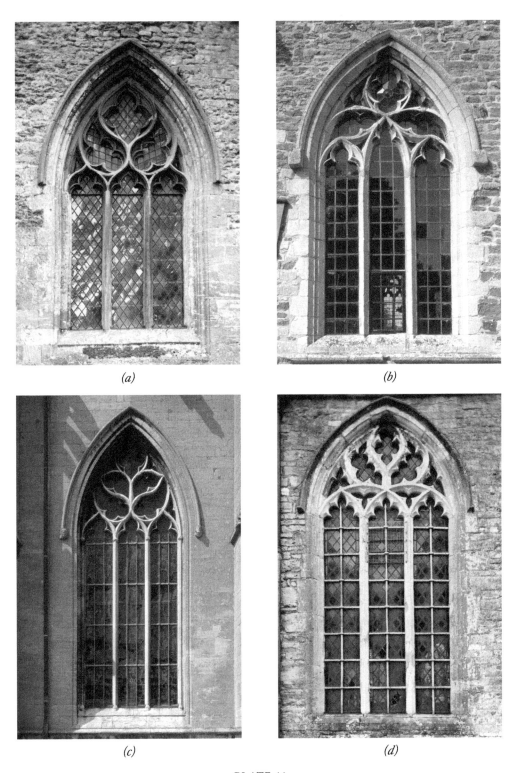

PLATE 46
*a. Horbling   b. Hallaton   c. Heckington   d. Raunds*

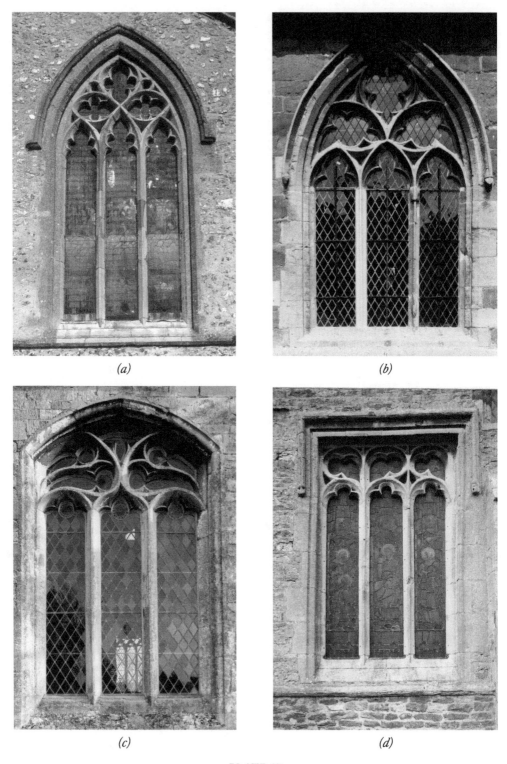

PLATE 47
*a. Snettisham   b. Ashby Folville   c. Folkingham   d. Glaston*

subarcuations flank the central feature of the five-light east window at Penkridge, Staffs, three Non-Coincident ones stand side by side in similar six-light windows at Sleaford and Newark, and in a seven-light window at Heckington *(Pl. 48b)* there is one each side of a central three-light subarcuation in which the mouchettes are downwardly convergent.

The simpler three-light versions can have pointed, ogee, trefoiled or cinquefoiled lights and employ essentially the same three tracery figures as the two-light windows though the vesical apex figure becomes rather larger or may vary. Windows at Horbling *(Pl. 46a)* and Kirby Bellars, Leics *(Pl. 55d)* among others have pairs of convergent falchions with downward orientation above lights of even height, and at Hallaton *(Pl. 46b)* a taller centre light gives convergent mouchettes an upwards emphasis. A chancel window at Ringstead is generally similar but has two pairs of convergent soufflet figures in its tracery. Divergent soufflet figures of a Snettisham window lie horizontally *(Pl. 47a)*, divergent multi-foiled falchions at Cotterstock have an upward orientation, and oddly angular ones at Ashby Folville *(Pl. 47b)* have a downward bias. In a further development, seen in three-light windows at Horbling and Heckington *(Pl. 46c)*, two tiers of falchions lie above the lights; a divergent upper pair interlocks with a convergent pair below.

The three-light windows at Raunds *(Pl. 46d)* and Ringstead, with segmental intersecting subarcuations that were referred to earlier, differ from the typical patterns described in that, above their subarcuations, a pair of crescent-shaped convergent falchions with downward emphasis embrace a foilated apex vesica.

Other peculiar designs exploit the fluid shapes of falchion figures in different ways. In a segmental pointed window at Folkingham *(Pl. 47c)*, a pair of irregular convergent falchion shapes each contain subordinate tracery of two mouchettes lying almost horizontally on top of each other, and at Glaston, Rutland *(Pl. 47d)* two asymmetrical straight-headed three-light windows, comprising two lights with convergent mouchette tracery and one with divergent (or vice versa – they can be read either way), are situated to balance one another each side of the south porch.

Among the larger falchion windows, a few can be selected that epitomise the exuberance and complexities of this flowing style. At Grantham, the westernmost of the three five-light windows in the south wall of the south chapel *(Pl. 48a)* has two two-light ogee subarcuations whose apices ascend vertically to define a broad centrepiece above the middle light that encloses a medley of intertwined mouchettes, bifoils and falchions flowing in all directions.

Despite the disconcerting imbalance of its subarcuations, the tracery of the seven-light east window at Heckington *(Pl. 48b)* forms a pattern on the grand scale of well-proportioned mouchettes, soufflets and falchions above seven trefoiled lights of the same height.

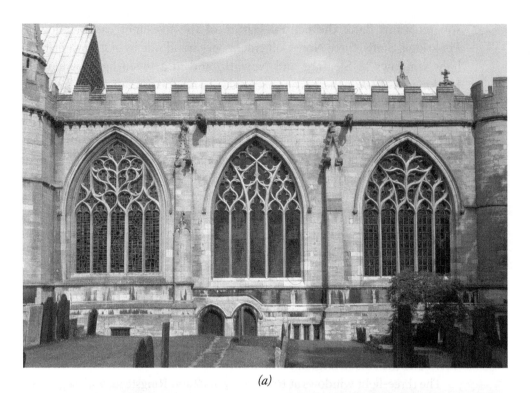

*(a)*

*(b)*

*(c)*

PLATE 48
*a. Grantham, south chapel   b. Heckington   c. Holbeach*

A four-light window in the chancel north wall at Holbeach *(Pl. 48c)* has a large pear-shaped central feature that encloses pairs of convergent and divergent falchions with big mouchettes at top and bottom, and within the ogee subarcuations on which it rests, converging falchions supporting a raindrop dagger figure are the predominant features.

The three windows described are in Lincolnshire churches. For spectacle and exuberance they are rivalled in Norfolk by the six-light west window at Snettisham *(Col. Pl. XII)* which is incomparable for the intricacy and small scale of the tracery pattern; a four-petal motif also known as cruciform lobing (see below) is repeated five times – in the headwork of the window's two subarcuations, within an ogee vesica and within falchions supported by mouchettes.

## PETAL TRACERY

The earliest Petal tracery in England is said to be that in the south walk of Norwich Cathedral cloisters of about 1325. It is a distinctive style in which four or more soufflets, vesical soufflets or slightly unbalanced quatrefoils radiate from a common central point like the petals of a flower.

In two-light windows such as one at Bozeat *(Pl. 49a)* and several in Norfolk churches, e.g. Brammerton and Woodton, cruciform lobing enclosed within a widened vesical shape forms the window's apex feature. In such designs, the four petals of the pattern are usually vesical or pear-shaped and foliated internally in soufflet form; they are generally disposed on the vertical and horizontal axes of their enclosing figure, and so their limbs form a diagonal cross in the centre. The window lights are usually ogee, although in a late Curvilinear/Early Perpendicular window at Walcott, Norfolk they are segmental headed and cinquefoiled.

A similar disposition of the 'petals' is followed in a three-light window at Snettisham, but there, instead of the usual soufflet form, they are broad mouchettes within a large circle resting on the ogee arch of a short centre light. In most three-light windows with a four-petal motif though, the apex of an ogee centre light extends to form a common vertical division between pairs of petals which, with a corresponding horizontal separation, establishes diagonal petal orientation. The tracery area containing the petals is defined by the extension of the inner ogee curves of the outer lights' arches to meet the window arch. In the windows of both aisles at Sutton, Cambs *(Pl. 49b)* and in those of many other churches elsewhere that adhere to this pattern, the petals are of normal shapes, but at Heydour *(Pl. 49c)* their outer ends are flattened where they meet the arches of the lights and the window. The residual voids at the apex and at the sides of the tracery in these windows are foliated curved-diamond shapes; by contrast, in a common arrangement in otherwise comparable windows at, for instance, Acle or Aylmerton in Norfolk

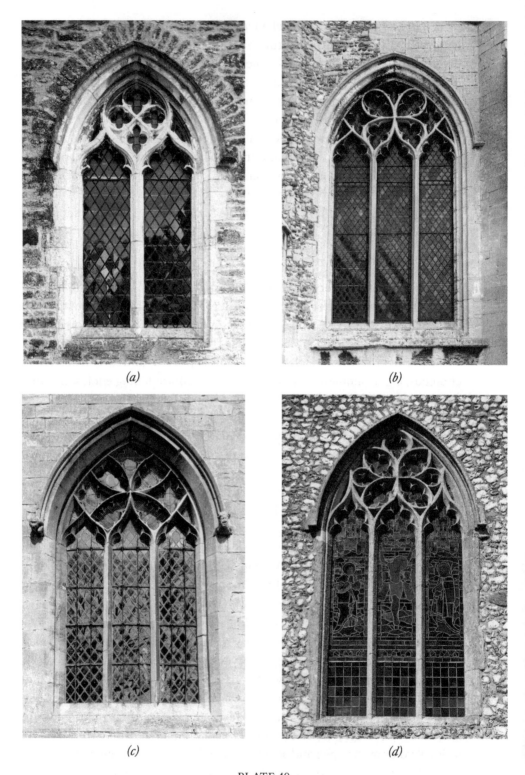

*(a)*          *(b)*

*(c)*          *(d)*

PLATE 49
*a. Bozeat   b. Sutton   c. Heydour   d. Aylmerton*

*(a)*          *(b)*

*(c)*          *(d)*

PLATE 50
*a. Frisby-on-the-Wreake   b. Holbeach   c. Attleborough   d. Boughton Aluph*

*(Pl.49d)*, additional small mouchettes or soufflets fill these spaces and the apices of the ogee outer lights extend vertically to the window arch.

The three-light windows described all have Non-Coincident side lights but where the outer lights are Coincident and the centre compartment widens towards the top as at Frisby-on-the Wreake, Leics *(Pl.50a)*, Petal tracery with five petals blossoming from the ogee apex of the lower middle light is a favoured centrepiece. The petals may be mouchettes or any of the soufflet variations, and the side lights of windows of this kind may have different treatments; whereas at Frisby-on-the-Wreake and in similar windows at Claypole two little mouchettes supporting a raindrop dagger form the side light tracery, a comparable window in the south aisle at Holbeach *(Pl.50b)* has trilobes in the apices of its side lights. An unusual variation of Petal tracery occurs in a window with Coincident side lights at Acle in which a curved lozenge shape above the middle light encloses the four-petalled flower motif, orientated as in the two-light windows.

Four or five petals are usual in this style of tracery, but occasionally odd variations are found. In a three-light south aisle window at Chipping Norton, the space above Non-Coincident lights is occupied exclusively by the seven petals of a flower design radiating from its central point; two of the petals are extended as elongated divergent mouchettes to fill the space above the outer lights.

The cruciform lobing pattern used in two-light windows recurs, encircled, in the apex of a four-light window at Grafton Underwood in which the tops of Non-Coincident mouchette subarcuations appear to have been deliberately distorted by mouchettes in the spandrels. It was also commonly adapted to fill modified vesical or falchion shapes in windows of other styles as in the apex features of the Reticulated windows at Great Walsingham and Tunstead mentioned above.

The large five-light west window at Attleborough *(Pl.50c)* incorporates two four-petal patterns. Two intersecting subarcuations of three lights have the Sutton pattern in their apices but the curved diamond apex of the window contains four petals orientated as in two-light windows.

As has been shown earlier, a visual structure of subarcuations supporting a circle in the apex of larger windows was not uncommon in the Geometric style and the pattern continued during the first half of the fourteenth century with Curvilinear tracery in the circle. In the four-light west window at Boughton Aluph *(Pl.50d)* Non-Coincident ogee subarcuations support a large circle whose tracery is a five-petalled flower. By contrast, although it has a similar format, the east window at Thurnham has pointed subarcuations, also Non-Coincident, and the tracery of its apex circle is not strictly Petal tracery; it has the so-called wheel motif – a series of trefoiled figures between 'spokes' radiating from a central quatrefoiled oculus.

## LEAFED STEM TRACERY

The identity of this style derives from a central vertical stem rising from the apex of a window's middle light, or from the central mullion of windows with two or four lights, and terminating in the window apex with a vesical soufflet. From the stem, opposed mouchettes or other figures extend in pairs like pinnate leaves. A precedent source for this theme is recognisable in the ubiquitous falchion pattern found in two-light windows as for instance at Somerby *(Pl.45b)*, or in the subarcuations of the four-light window at Gaddesby *(Pl.45d)*, then evolving in three-light windows like those at Kibworth *(Pl.45a)* or Heckington *(Pl.46c)*. It becomes more fully developed in three-light windows when the side lights are Coincident and consequently taller than the middle light, and their inner curves define a widening central compartment.

In most windows of this style with an odd number of lights, the central head tracery consists typically of five figures – two pairs attached to the stem rising from the apex of the middle light and the apex vesica. The upper figures branching from the stem are usually divergent falchions and the figures of lower pairs, not always leaf-like, may adjoin the stem rather than branch from it. In a three-light chancel window at Holbeach *(Pl.51a)*, the two lower figures are foliated segment shapes, and in a five-light window at Snettisham *(Pl.52b)* they are small mouchettes alongside the stem. The Leafed Stem motif is sometimes not easily differentiated from five-petal flower tracery of the kind in the Frisby window *(Pl.50a)*.

In four-light windows the essential difference from three-light types is that the stem ascends from the central mullion, and the resulting patterns can be influenced by whether the window's subarcuations are Coincident or Non-Coincident. The curved diamond apex space defined by pointed Coincident subarcuations in the window at Gaddesby *(Pl.45d)* has the simplest form, with only a single pair of figures below the apex vesica, but at South Wooton, Norfolk *(Pl.51b)* a display equivalent to the Frisby *(Pl.50a)* pattern occupies the apex space. Where subarcuations are Non-Coincident the space above allows more flexible designs like the tulip shape in one of the Sleaford windows *(Pl.51c)* or a wider spread as in one of the several Curvilinear patterns at Boston, Lincs *(Pl.51d)*; in another Sleaford window *(Pl.5b)*, the inner curves of its two ogee subarcuations continue upwards to create a large vesica enclosing a Leafed Stem display within, extending from the central mullion. By contrast with those curving lines, the apices of the subarcuations in a comparable four-light window also at Frisby-on-the-Wreake *(Pl.52a)* extend vertically upwards to meet the window arch, thereby creating a parallel-sided centrepiece in which two pairs of divergent falchions above a pair of curving pointed bifoils support the apex vesica.

(a)

(b)

(c)

(d)

PLATE 51
*a. Holbeach   b. South Wooton   c. Sleaford   d. Boston*

(a)

(b)

(c)

(d)

PLATE 52
*a. Frisby-on-the-Wreake   b. Snettisham   c. Boothby Pagnell   d. Ingham*

The widening central compartments of five-light windows with two-light subarcuations are well suited to this style, as is shown in the south transept window at Snettisham *(Pl.52b)* and in the easternmost window of three in the south wall of the south chapel at Grantham *(Pl.48a)*. Both have Coincident mouchette subarcuations but their central treatment differs. At Snettisham, the apex of the middle light develops into a five-element centrepiece, but in the Grantham window, the middle light apex becomes the stem of a centrepiece of seven elements. The beauty of these two windows derives from their good proportions and the pleasing balance of the sizes of their components.

Comparison of the east window at Soham *(Pl.57b)* with the central one in the south chapel south wall at Grantham *(Pl.48a)* demonstrates the close affinity between Petal tracery and the Leafed Stem motif. Both have five lights with two two-light Coincident subarcuations similarly but not identically traceried. In the widening central compartment at Soham, the apex of the middle light develops initially as a leafed stem with two opposed pairs of figures above which a four-petalled flower figure, as used in the three-light Sutton windows *(Pl.49b)*, is the focal centrepiece; at Grantham, an incipient Leafed Stem development in the centre compartment has only one pair of opposed figures but the stem continues upwards as the division between the two lower petals of a five-petal flower centrepiece *(Pl.50a)* in the style of the three-light Frisby window.

Striking, but less successful aesthetically, is the east window at Boothby Pagnell *(Pl.52c)*; it has five equal Non-Coincident lights, with a strong Leafed Stem motif developing from the apex of the central one, but irregularity and distortion in the four motifs in the valleys between the lights' ogee arches, and other imbalances result in an uncomfortable design.

A visual framework that differs from the above examples is followed in the five-light east window at Ingham *(Pl.52d)* where Coincident single outer lights and a matching middle light define two intermediate compartments widening at the top; each displays Leafed Stem patterns of broad converging and diverging mouchettes.

## FLAMBOYANT TRACERY

In its wider non-architectural sense, the term Flamboyant has connotations of extravagant flowery decoration and could apply to many Curvilinear windows, but in English tracery its meaning is limited specifically to patterns in which the figures have a flame-like appearance.

The chief characteristic of the style is its sense of upward flowing movement, often culminating with a vesica in the window apex. Curvaceous foliated piercings, usually asymmetrical and pointed at both ends and typically of elongated soufflet, mouchette or other bifoil shapes, are bounded by wavy

(a)

(b)

(c)

(d)

PLATE 53
*a. Burton Lazars   b. North Leverton   c. Cromwell   d. Bolton Abbey*

mouldings prolonging or branching from the mullions. In some designs, though, the apices of ogee lights extend up to the window arch in straight lines, indicating an influence of the emerging Perpendicular style.

Flamboyant tracery never became widely established in this country, though a few examples appeared in the middle of the fourteenth century towards the end of the Curvilinear period. In the second half of the century the Perpendicular style was gaining ascendancy in England, superseding the flowing Curvilinear styles and probably militating against the development of a universal indigenous Flamboyant style. As a developed architectural style, Flamboyant is properly a later phase of Continental Gothic architecture that was emerging in France during the last quarter of the fourteenth century.

In English interpretations, Flamboyant tracery at its very simplest occurs in the form of curved mouchette-like figures. In contrast to the divergent mouchettes commonly used in two-light falchion windows like, for example, the one at Somerby *(Pl. 45b)*, crescent figures above trefoiled but slightly ogee lights in two-light windows at Burton Lazars *(Pl. 53a)* and Aldwinkle *(32a)*, curve inwards at the top to embrace the apex vesica; in both, their upwards sweep and pointed top and bottom lobes give them flame-like inflections.

The flame-like tracery of a remarkable three-light chancel window at North Leverton *(Pl. 53b)* is, except for its apex quatrefoil, composed entirely of ten elongated curved and pointed soufflets all with a pronounced upward curvature, and other chancel windows at this church with unusual tracery patterns also display Flamboyant tendencies.

Elsewhere, two-light windows manifest other Flamboyant tendencies. At Etchingham cinquefoiled ogee arches support four pointed soufflets with smaller curved ones flanking the apex vesica above, and at Cliffe the top of the lights of two different window types are asymmetrically deformed as in the aisle west windows at Howden *(Pl. 41a)*, to accommodate the apex figure; the effect is to induce Flamboyant curvature to the tops of its flanking soufflets.

Two ogee vesicas side by side each containing a pair of ogee mouchettes, one inverted, are the dominant features of the tracery of two almost identical fourteenth-century three-light windows at Hawton and Cromwell, Notts *(Pl. 53c)*. This characteristic motif of Flamboyant tracery also occurs in the apex of one of the south windows at Car Colston, Notts although that particular window may be a restoration.

In a window of the ruined fourteenth-century chancel of Bolton Abbey, Yorks *(Pl. 53d)*, the twelve flexuous figures of its tracery comprise amorphous trefoiled shapes and irregular pointed and curved soufflets comparable to the ascending ones in a window at Kirby Bellars *(Pl. 55d)*. Their combined effect and upwards emphasis give this window an unmistakable, if temperate, Flamboyancy.

*(a)*          *(b)*

*(c)*          *(d)*

PLATE 54
*a. Salford Priors   b. Chipping Norton   c. Brede   d. Oxford*

The clarity of ascending flow in a Flamboyant composition is nowhere better shown than by the affinity between the curving bifoils of windows in the north aisle at Salford Priors, Warks *(Pl.54a)*. A comparable north window at Chipping Norton *(Pl.54b)* has a different pattern but its curved elongated soufflets and inverted daggers impart strong upward movement in the same way.

Based on the pattern of two curved mouchettes with one reversed, similar to the device used at Hawton and Cromwell but larger, a three-light window in the south chapel at Brede, Sussex *(Pl.54c)* is said to date from 1537, almost two centuries after the brief life of the style in earlier medieval times. Evidence that this window is unlikely to be a more recent restoration is provided by a lead flashing in the wall immediately adjacent to the window on which the date 1667 is inscribed. The tower of St Mary Magdalen church in Oxford, said to have been rebuilt in 1511-31, provides another late flowering. It has a three-light window whose sinuous bifoils embracing curved soufflets give it a strong Flamboyant character *(Pl.54d)*; its design is essentially similar to the Salford Priors window, the difference being the two wider soufflets at Oxford compared to the narrower bifoils at the former.

In other two-light windows at Car Colston *(Pl.55a)* and at Muston pointed bifoils above ogee lights are the Flamboyant elements of a trend in which the apices of the lights extend vertically to the window arch. The same tendency occurs in the three-light south aisle windows at Deeping St James, Lincs *(Pl.55b)*, and in one at Soham *(Pl.55c)*, whose tracery theme is of the same type, the Perpendicular influence is more fully developed in that the mullions extend through to the window arch.

On a larger scale, a sinuous pattern of varied soufflets and elongated pointed bifoils bounded by wavy stone members gives a pronounced flame-like upwards flow to the intricate tracery of the five-light east window at Elsing, Norfolk *(Col.Pl.XIII)*, datable from about 1330. Depending on where the limits are drawn for the definition of Flamboyant tracery, other large windows with asymmetrical traceries such as those at Heckington *(Pl.5c)*, Sleaford and Cromwell could qualify for inclusion within the style by virtue of their curving falchion motifs and the tortuous upflows in their skeletal frameworks. The style's upwards emphasis is also induced, though in a different way, by the large falchion figures in the six-light west window at Snettisham *(Col.Pl.XII)*, but their impact is lessened by the prolific subordinate motifs that they enclose.

In looking for possible origins of this short-lived style, the tracery of the simple window at Burton Lazars and its recurrence in modified form in the three-light Oxford window could be understood as a reference to reticulation units in which curved elongated bifoils embrace an ogee vesical shape, such as those in window at Great Ryburgh *(Pl.44d)*. Resembling tongues of flame,

PLATE 55
*a. Car Colston   b. Deeping St James   c. Soham   d. Kirby Bellars*

the falchions in the Horbling windows *(Pl. 46a)* and others elsewhere that embrace the apex figure can also be seen as parallels with the Burton Lazars motif, though on a larger scale. Ignoring the downward orientation imparted by their subordinate internal cusping, their outlines have an upward impetus analogous to the Burton Lazars mouchettes. Alternatively, a parallel can be drawn between the irregular soufflets in the Bolton Abbey window *(Pl. 53d)* and those with curved tips at Kirby Bellars *(Pl. 55d)* comparable to the Horbling falchions.

## ASYMMETRIC SUBARCUATIONS

Though strictly not a tracery style, many Curvilinear windows have a distinctive, if restless, appearance because of a conspicuous asymmetrical bias in their composition. This is more often manifest in the skeletal frameworks of larger windows with an odd number of lights, and generally results from the enclosure of unbalanced elements within subarcuations that may themselves be lop-sided.

The five-light east window at Cotterstock *(Col. Pl. XIV)* and the similar one at Ringstead *(Pl. 5d)* both have Coincident two-light subarcuations but the symmetry of these is distorted by a reversed ogee twist at the top of the inner curve of their arches like the Howden windows *(Pl. 41a)* on a larger scale. This appears to have been done to accommodate the curvature of large upper falchions in their Leaf Stem centrepiece above the middle light. More worrisome are the distortions and confusions of a five-light window in the south transept at Heckington *(Pl. 5c)* and comparable ones over the west door at Sleaford and the east window at Cromwell; of similar general compositions, their tortuous intersections produce not only unbalanced subarcuations but different curvatures on each side of their arches. Similar visual imbalances also occur in the seven-light east windows at Heckington *(Pl. 48b)* and Hawton where misshapen concave squares in the valleys between two-light and three-light pointed subarcuations form the apices of bigger, ogee, asymmetrical, five-light intersecting subarcuations.

Asymmetry is also found in smaller windows as in the aisle west windows at Howden referred to above, and instances also occur in three-light windows with a taller middle light and convergent falchion tracery such as those at Hallaton *(Pl. 46b)* and others with a taller middle light as at Lyddington, Ufford and Ringstead. In windows of this pattern, intersecting round-headed two-light subarcuations embrace a short side light and the taller middle one despite their height disparity; elongated soufflets lying over the short light serve as part of the arch of the subarcuations. Being part of the tracery pattern, this asymmetry is less visually disruptive than when a dominant part of the framework of larger windows.

## UNCLASSIFIED CURVILINEAR

In a group of styles with such an extensive vocabulary of motifs derived from the ogee form, it is inevitable that there will be some Curvilinear designs that did not gain a wide acceptance and do not conform with any of the categories discussed above. For instance, of the eight different windows in the north and south chancel walls at Lawford, Essex some have out-of-the-ordinary, perhaps unique, tracery patterns *(Col.Pl.XI)* and yet appear alongside typical designs.

Another unusual pattern is found at Billingborough where a two-light window with trefoiled pointed lights *(Pl.56a)* has Strap tracery comprising two trefoils with ogee top lobes on which rests a third with round lobes – an ogee analogy perhaps to Late Geometric windows at Rippingale *(Pl.27d)*, less than five miles away.

Particular individual motifs may have been popular in a few windows but not to the extent of establishing a style. The mouchette wheel for example, (two or more mouchettes within a circle chasing each other) occurs with two mouchettes at Ancaster, Lincs *(Pl.56b)*, with three at Burton Coggles *(Pl.56c)*, and in versions with three and four in Strap tracery at Caythorpe *(Pl.11a)*.

An unusual motif, probably of the Late Geometric period, that was not widely adopted occupies the apex of a two-light window with trefoiled lights at Stibbington *(Pl.56d)*. It is an unencircled cruciform quatrefoil with pointed lobes of different shapes; the lower one is elongated, the top one shorter and the side ones have almost straight top edges.

There are also many windows that, having features of more than one Curvilinear style, do not fit unambiguously into one specific category. Frequently a design may combine stylistic themes like Petal or Leafed Stem with different motifs such as reticulation units, falchions, or vesicas, but lack a defining predominance. As examples of many cases of this kind, the east window at Etchingham *(Pl.57a)* has a tier of four standard reticulation units above its five lights and above those a complexity of falchions and a four-petal flower pattern, and at Soham *(Pl.57b)* a five-light window has a four-petal flower motif above a leafed stem in its centrepiece and large vesicas containing flexuous soufflets in its Coincident subarcuations of the style of those in the Attleborough window *(Pl.32d)*.

The common factor of the tracery patterns of another group of windows is that while still retaining a distinctively Curvilinear appearance, they incorporate characteristics of the Perpendicular style. In a three-light window at Kislingbury *(Pl.57c)*, the intersecting arches of its ogee subarcuations enclose a vesical apex figure, but Perpendicular elements are introduced in the form of short straight vertical members rising from the apices of the outer lights. At Sutton, the tracery of the five-light east window *(Pl.57d)* is composed mainly of vigorous curvilinear motifs but certain of the figures

PLATE 56
*a. Billingborough   b. Ancaster   c. Burton Coggles   d. Stibbington*

*(a)*

*(b)*

*(c)*

*(d)*

PLATE 57
*a. Etchingham   b. Soham   c. Kislingbury   d. Sutton*

113

in its centrepiece have straight sides and the incipient Perpendicular sense that this imparts is reinforced by a battlemented transom in the window lower down.

COLOUR PLATE I  *Late Geometric tracery in window of ruined refectory, Little Walsingham Prory.*

COLOUR PLATE II *Spherical square and pointed cruciform quatrefoils in large west window, Howden.*

COLOUR PLATE III  *Vesical motifs in subarcuations of south transept window, Northborough.*

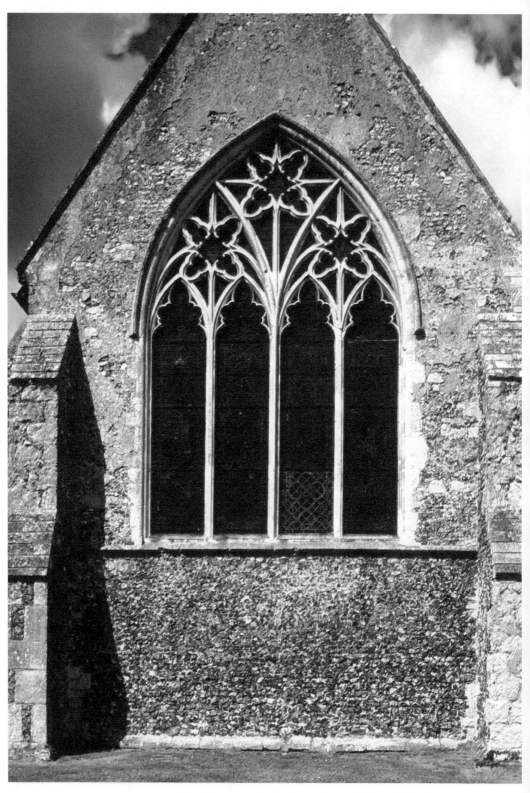

COLOUR PLATE IV *Kentish tracery in the chancel east window, Chartham.*

COLOUR PLATE V  *Intersecting tracery lavishly ornamented with ballflower in the tower west window, Grantham.*

COLOUR PLATE VI  *Cusped Intersecting tracery in the nave west window, Melton Mowbray.*

COLOUR PLATE VII *Late Geometric motifs in east window of south aisle, Chipping Norton.*

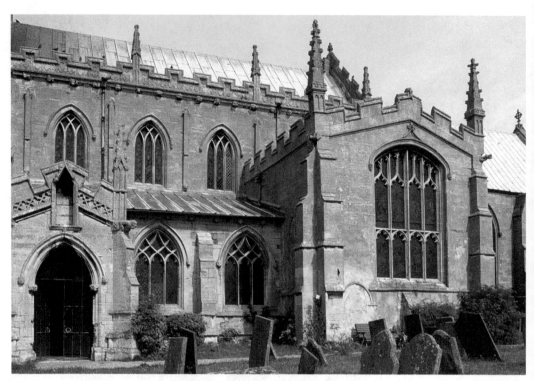

COLOUR PLATE VIII *Intersecting tracery in clerestory, Ogee Interesecting in aisle, Perpendicular in transept, Claypole.*

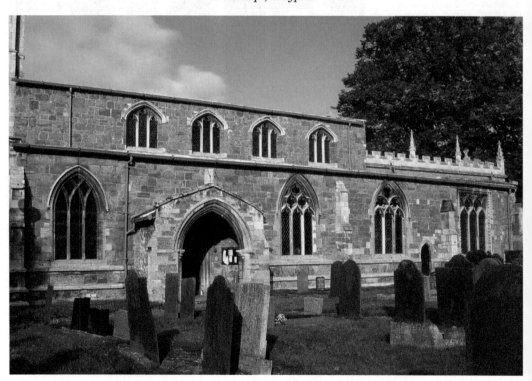

COLOUR PLATE IX *Intersecting and varied Curvilinear tracery in aisle windows, Ashby Folville.*

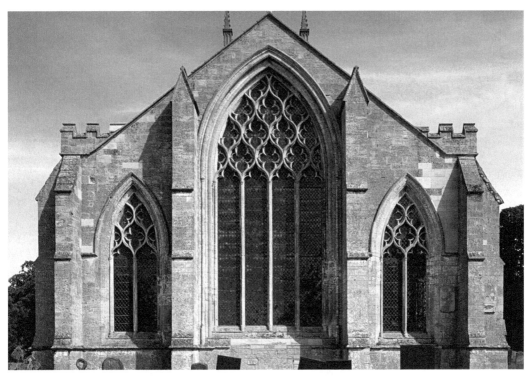

COLOUR PLATE X *Reticulated tracery in west windows of nave and aisles, Swaton.*

COLOUR PLATE XI *Different and unusual Curvilinear tracery patterns in the chancel windows, Lawford.*

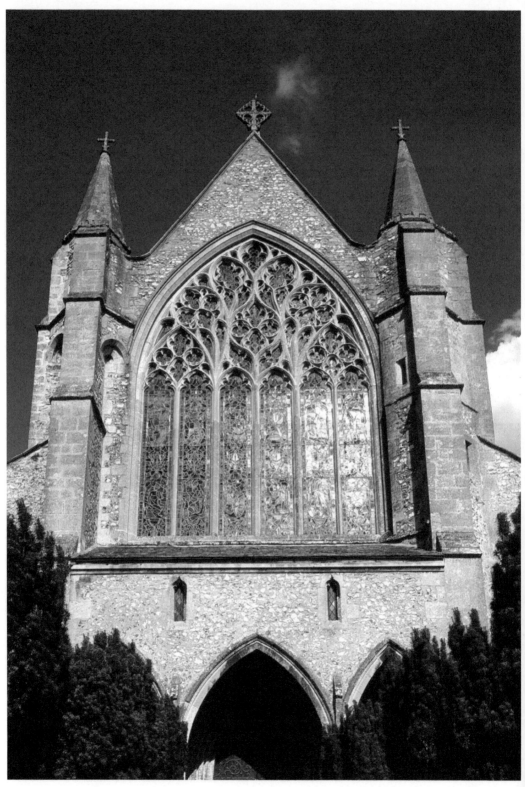

COLOUR PLATE XII  *Cruciform lobing and falchions in tracery of nave west window, Snettisham.*

COLOUR PLATE XIII *Flamboyant tracery in east window, Elsing.*

COLOUR PLATE XIV  *Distorted subarcuations in Curvilinear tracery of east window, Cotterstock.*

COLOUR PLATE XV  *Short latticed supertransom in centre compartment of Perpendicular window with Supermullioned Drop tracery at Archbishop Chichele's School, Higham Ferrers.*

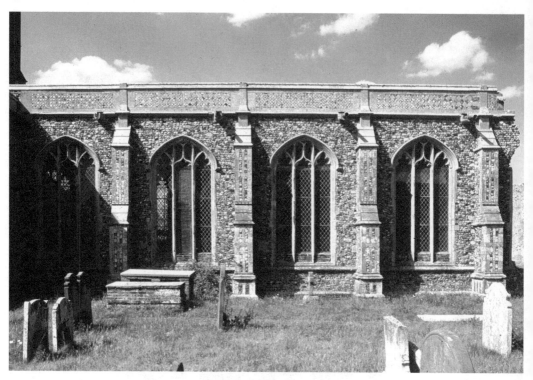

COLOUR PLATE XVI  *Simple Perpendicular tracery with supermullions in the centre lights only, Walberswick.*

COLOUR PLATE XVII  *Supermullioned Drop tracery in four-centred arches of clerestory windows, Wortham.*

COLOUR PLATE XVIII *Short supertransoms in the tracery of the tower window subarcuations, Southwold.*

COLOUR PLATE XIX  *Unique diagonal tracery pattern covering the whole of the east window and extended as flushwork over the rest of the wall, Barsham.*

CHAPTER 7

# Perpendicular Styles

The overriding impression of Perpendicular tracery is its emphasis on verticality. This derives principally from members of the tracery rising vertically without deflection to meet the curve of the window arch, and from the transition of reticulated Curvilinear figures into hexagonal shapes with straight vertical sides. The tracery's straight members are formed by the upwards prolongation of the window mullions from the springing level of the arches of the window lights or by shorter vertical bars rising from the apices of the lights that delineate or subdivide the tracery lights.

By the inclusion of vertical tracery members, visual framework formats are introduced that are relevant only to Perpendicular styles. The main element of configurations additional to those described in Chapter 2, is the continuous mullion running uninterruptedly from the window cill to the window arch. This Perpendicular format may be superimposed on other frameworks or it may establish a visual predominance independently. In some windows with this feature, all the mullions run through *(Pl. 61)* and in others with an odd number of lights *(Pls. 4a and 62c)*, a central compartment is defined by two main mullions rising from cill to windowhead, or more rarely in those with an even number of lights, two full-height central compartments *(Pl. 65a)*.

Being specific to Perpendicular windows, these formats could be regarded as part of the style, but since they are common to several different Perpendicular tracery styles, they may also equally be interpreted as elements of visual structure.

Subarcuations are important visual elements of large Perpendicular windows with multiple lights and it is noteworthy that, whether separate or intersecting, they are usually Coincident with the window arch. Ogee subarcuations are unusual in Perpendicular windows, and use of the ogee form

tends to be limited to the arches of individual lights and to curvilinear motifs that may be incorporated in the tracery.

Three distinctions of Perpendicular tracery were identified and named by Freeman in the nineteenth century and still form a recognised basis for differentiation of style; they can be summarised as follows:

> *Alternate*: Tracery forms based on straight-sided reticulation units analogous to vertically elongated hexagons whose sides rise from the apices of the window lights.
>
> *Supermullioned*: Tracery in which the principal window mullions extend from cill to windowhead. Secondary mullions rising from the head of each light that divide the tracery panel above into two half-width panels are also known as supermullions, as are the attenuated mullions prolonging principal mullions above the springing level of the lights.
>
> *Panelled*: Only the mullions between the lights extend from window cill to head; the full width of the lights continues up to the window arch without supermullioned subdivisions. However, the expression Panel Tracery is now also widely used as a general description of any supermullioned gridiron style.

The almost universal use of supermullions rising between the window lights and from their apices in many Perpendicular window designs has generated the most characteristic motif of Perpendicular styles – an upright 'panel' with straight sides having a foliated head either trefoiled or cinquefoiled and an asymmetrical base dictated by the shape of the arch on which it rests; from the manner in which it has come into being, it is inevitably half the width of the window lights and could therefore conveniently be described as a demi-panel.

## ALTERNATE TRACERY

The earliest Perpendicular tracery is considered by leading architectural historians to be that of the documented windows of the Chapter House of Old St Paul's, London followed shortly by the south transept windows of Gloucester Cathedral, both datable to the 1330s. It appears though, that it was not until about a generation later that the ideas originated there were more widely disseminated. Dated to between 1352 and 1361, the side windows of the chancel and those of the south transept of Edington church, Wilts *(Pl.58a)* comprise three cinquefoiled lights supporting two foliated reticulation figures with a third in the apex whose straight sides, extending to the window arch, create the hexagonal shape that is the hallmark of Alternate style. In a

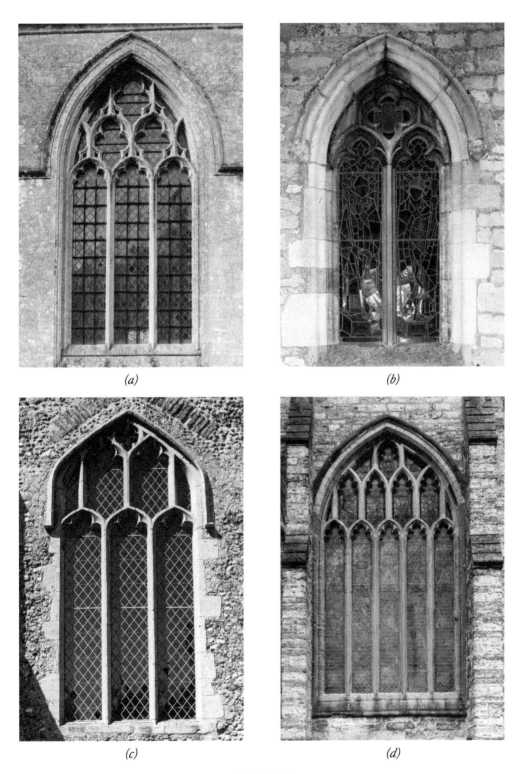

*(a)*  *(b)*

*(c)*  *(d)*

PLATE 58
*a. Edington   b. Colsterworth   c. Necton   d. Yeovil*

117

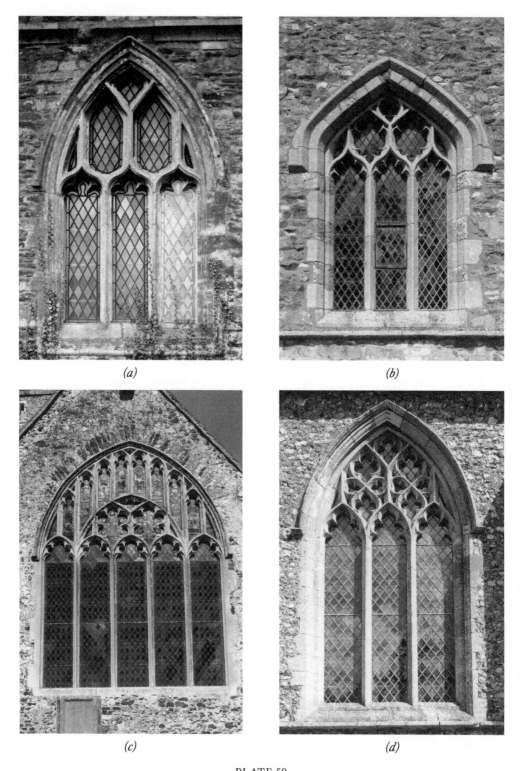

PLATE 59
*a. Glaston   b. Gaddesby   c. Boughton Aluph   d. Beeston St Lawrence*

comparable though probably later window at Swanton Abbotts, Norfolk, the two lower figures are also hexagonal with straight sides and double cusping within. On a smaller scale, comparison of the Curvilinear two-light window at Carlton Scroop *(Pl.38b)* with one of the same configuration at Colsterworth, Lincs *(Pl.58b)* illustrates how small a variation is needed to transform the curved apex figure of the former into a straight-sided hexagonal equivalent at the latter.

The peculiar hexagonal tracery of one of the three-light window in the south aisle at Quarrington has sown seeds of doubt as to whether it is a medieval window, but close inspection of its stonework does not reveal any evidence to suggest that it might be a fanciful Victorian restoration. Above three equal cinquefoiled lights are three straight-sided hexagons and within these, trefoils whose lobes are separated by V-shaped split cusps, wider than the normal Kentish type. The hexagons are equal-sided, the only imperfection in their shape being in the top one whose top two sides are formed by the arcs of the window arch; the hexagons are pure geometric figures, and the window has no ogee elements.

The Edington windows have equilateral pointed arches but where three-light windows have lower arches or taller hexagons as at Ingham or Necton, Norfolk *(Pl.58c)*, the outer sides of the hexagons extend to the window arch, and there is only sufficient space at the apex for a small eyelet instead of a third hexagon. In the five-light windows at Yeovil, Somerset *(Pl.58d)*, by contrast with the diminishing tiers of Curvilinear reticulation units in windows like the one at Norton Subcourse *(Pl.43b)*, the four tall hexagons in the first tier above the lights allow space for only one hexagon in the window apex. At Edington the hexagons are quatrefoiled, at Necton and Yeovil only their heads are foliated and at Ingham they are multifoiled.

The lights of the windows mentioned above have pointed arches but there are many of this pattern with ogee lights – in pointed windows at Glaston *(Pl.59a)* the hexagons are unfoliated and at Raunds multifoiled, and beneath four-centred arches at Wanlip, Leics and Gaddesby *(Pl.59b)*, multifoiled.

A most unusual application of the twin hexagon format occurs in a window at Boughton Aluph *(Pl.59c)*. It has five equal lights of which the middle three, surmounted by a pair of foliated hexagons, form a subarcuation under an obtuse two-centred pointed arch. The window arch follows the curves of this subarcuation, and the curved space between the two arches is occupied by a series of demi-panels; this creates the impression of a small window within a larger one.

Several churches in north-east Norfolk that include Trunch with tall two-light windows and Ingham, Tuttington, Walcott and Beeston St Lawrence *(Pl.59d)* to name a few with three-light windows, have Alternate tracery, but their hexagons are filled with the cruciform lobing motif or minor variations

of it similar to the patterns used in the two-light Curvilinear windows at Brammerton and Woodton. Except at Beeston St Lawrence, the windows of this type at the other churches are alongside others of the same size that have Alternate Supermullioned tracery; this suggests a common date for the two types probably in the third quarter of the fourteenth century or a little later, during a period of overlap between Decorated and Perpendicular styles.

A small quatrefoiled ogee vesica above or below a short supermullion is another motif commonly used within straight-sided hexagon figures, particularly in two-light windows such as those at Weybourne, Norfolk and Blundeston.

In a window with a four-centred, segmental or flat head, the tracery area above the lights is usually less than in those with a normal pointed arch. It has been shown in Chapter 6 that in such cases the reticulation units of windows like the one at North Elmham *(Pl.44a)* may be cut to half their height; in comparable circumstances, hexagons of Alternate tracery are similarly affected. Where the windowhead is segmental or segmental pointed, as in the three-light windows at Beckingham, Notts and Donnington, Lincs, the apices of ogee lights below extend upward to the arch as short supermullions, thereby marking the windows as Perpendicular even though the window mullions do not extend to the arch. There is otherwise no significant difference between these and their Curvilinear equivalents. The practice is therefore perhaps best understood as another manifestation of the overlap between Decorated and Perpendicular, particularly since, in these two windows, the resulting asymmetrical truncated-hexagon figures accommodate curvilinear pointed trefoils. Prolongation of the apices of ogee lights to the window arch at Car Colston *(Pl.55a)* and similarly at Deeping St James *(Pl.55b)* and Soham *(Pl.55c)* in the context of Flamboyant tracery has been mentioned in Chapter 6, and could perhaps be regarded as a logical development of the configuration described above in cases where the window has a normal pointed arch.

## ALTERNATE SUPERMULLIONED

In this tracery style, elongated hexagons whose vertical sides are supermullions rising from the apices of the lights below are subdivided by a subordinate supermullion of diminished section that rises from the window mullion, forking at the head to form a small diamond eyelet; this creates a mirror pair of demi-panels within each hexagon, usually with trefoiled heads.

The two-light chancel windows with trefoiled lights and a single apex hexagon at Sandon, Herts *(Pl.60a)* may be the prototypes of this design, probably dating from about 1360. Thereafter the theme was not uncommon during the period of the Decorated to Perpendicular overlap in the third quarter of the fourteenth century. Three-light windows have two hexagons,

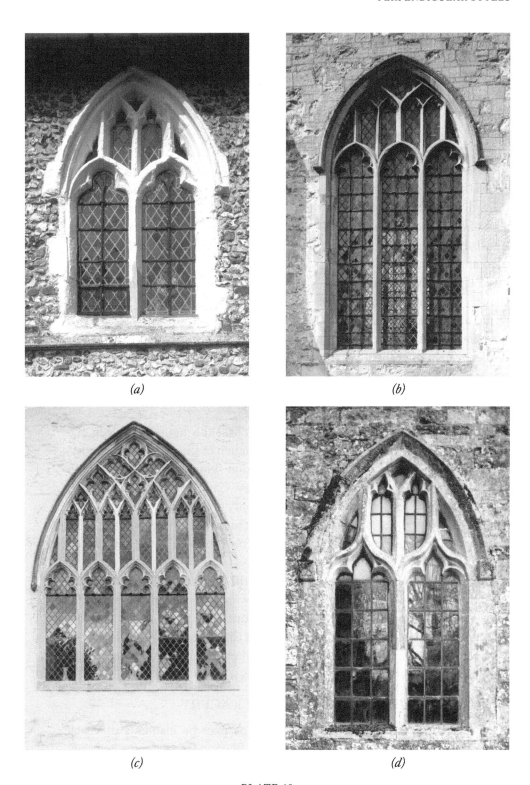

(a)

(b)

(c)

(d)

PLATE 60
*a. Sandon   b. Ashwell, Herts   c. Harlton   d. Coston*

121

usually with a quatrefoil in the window apex between them echoing the eyelet motif of their hexagons; those at Ashwell, Herts *(Pl.60b)* are typical, and at Bulwick there are two versions – with pointed lights and with ogee lights. Three of the churches in north-east Norfolk referred to above have windows with this style of hexagon adjacent to those with cruciform-lobed hexagons.

The striking five-light east window at Harlton, Cambs *(Pl.60c)*, which is identical to the one at Ashwell about twelve miles away, has four hexagons in pairs beneath Coincident arches whose inner curves spring from the central supermullion; above them a flowing four-petal flower motif in the large curved diamond apex illustrates the continuation of Curvilinear features into early Perpendicular tracery. The visual structure of these two windows is unusual because the Coincident arches enclosing the paired hexagons make incomplete subarcuations.

In many windows of this kind, the upper arcs of the hexagon arches where they meet the window arch appear almost straight, giving a very angular apex to the top of the hexagon and this is often reflected in the window tracery as a whole, as seen in the Ashwell and Harlton windows. By contrast with this tendency, in a three-light window of this style at Morcott, Rutland the inner upper arcs of the hexagons have smaller radii than the window arch, making the hexagons asymmetrical, and the demi-panels within them have almost semi-circular heads.

Where the window lights have ogee arches, the figures between the supermullions that rise from their apices lose much of their hexagonal clarity, as is shown in the ogee version of the Sandon window design at Coston *(Pl.60d)*, and in a four-light window at Maxey, Cambs the tracery becomes barely recognisable as Alternate because not only do the window's ogee lights distort the lower arcs of the three figures that would be expected to be hexagons, but the upper arcs of those figures are also broken by the penetration of other motifs.

In most Alternate windows the arches of the lights are at the same level, usually at the springing level of the window arch as at Harlton, but in an unusual window at Caythorpe *(Pl.21a)* with four lancet lights the two middle ones are taller than the outer ones. This means that there is only one hexagon, between the arches of the two middle lights, whereas had they been level with the outer lights there would be space for three.

## THROUGH MULLIONS WITHOUT TRACERY

As has been shown above, through mullions may be elements of visual framework rather than style motifs, e.g. as in Pl.65; nevertheless, when they are the only Perpendicular feature of a window, they necessarily become a defining part of its style. Through-mullion windows without tracery apart from foliations in the arches of the lights fall into this category. These are the

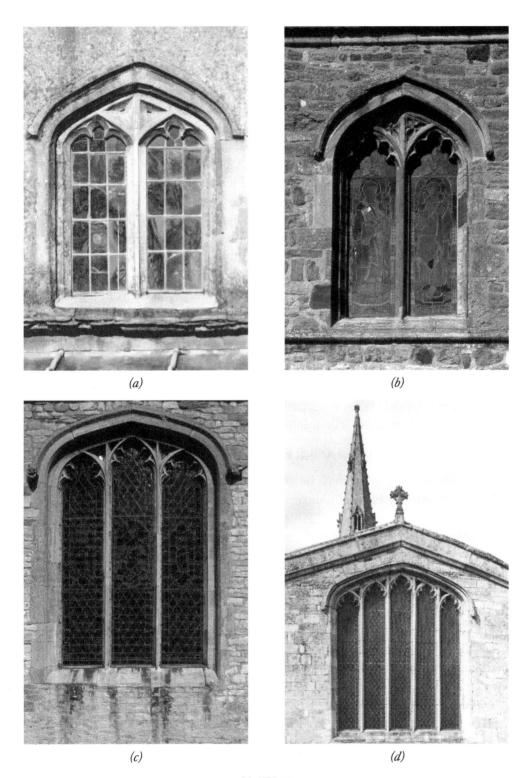

(a)

(b)

(c)

(d)

PLATE 61
*a. Little Casterton   b. Earls Barton   c. Tinwell   d. Wakerley*

simplest forms of Perpendicular window though the arches of the lights may be either trefoiled or cinquefoiled. Their Perpendicular identity derives from their through mullions which extend to the window arch. This pattern is the equivalent of the Lancet style east windows of Etton *(Pl. 19d)* or Gaddesby. Continuation of the mullion through to the apex is not common in two-light windows of this type but there are instances, such as in the clerestory at Little Casterton *(Pl. 61a)* where a short supermullion divides the apex space into two spandrel sinkings beneath a four-centred arch. A small window at Earls Barton *(Pl. 61b)* is similar, but its spandrels are carved with relief decoration instead of being sunk or pierced for glazing. In other contexts though, continuation to the apex of a central mullion between two lights is occasionally seen, for example in the Drop tracery of the two-light subarcuations in a five-light window with central through mullions at Archbishop Chichele's School next to the church at Higham Ferrers *(Col. Pl. XV)*.

Three-light cinquefoiled examples at Tinwell *(Pl. 61c)* and Lyddington have four-centred window arches of different pitches with Coincident outer lights, and there are five-light versions, also under four-centred arches, at Wakerley *(Pl. 61d)* and Brigstock, Northants. Whether or not smaller windows such as these, having no transoms to divide them into panels, should legitimately be classed as panelled and qualify as conforming with Freeman's definition may be debatable, nevertheless their comparable appearance with transomed examples makes it convenient to consider them as visually related.

## SUPERMULLIONED TRACERY

Supermullioned windows may be of any size from two-light windows with a single tracery band of four demi-panels to the largest windows with many lights.

Many two-light windows, particularly clerestory windows, have four-centred or segmental arches with Drop tracery of four demi-panels, and often it is only the full thickness of the central mullion of the tracery that differentiates them from comparable Alternate windows with a supermullion in the hexagon. Almost invariably in two-light windows the central mullion is not carried quite up to the arch as that would produce an unsatisfactory visual duality; instead, the mullion forks at the apex to form a small triangular piercing as in the clerestory windows at Wortham, Suffolk *(Col. Pl. XVII)*, or an eyelet as in the subarcuated version in Badwell Ash porch, Suffolk *(Pl. 62a)*.

The simplest traceried three-light windows just have a pair of demi-panels in the middle light as at Hemblington *(Pl. 62b)* whose outer lights are trefoiled, or at Walberswick, Suffolk *(Col. Pl. XVI)* where the lights of the nave south windows are cinquefoiled. More typically, a band of tracery extends over the three lights, comprising four demi-panels with spandrel piercings at the sides

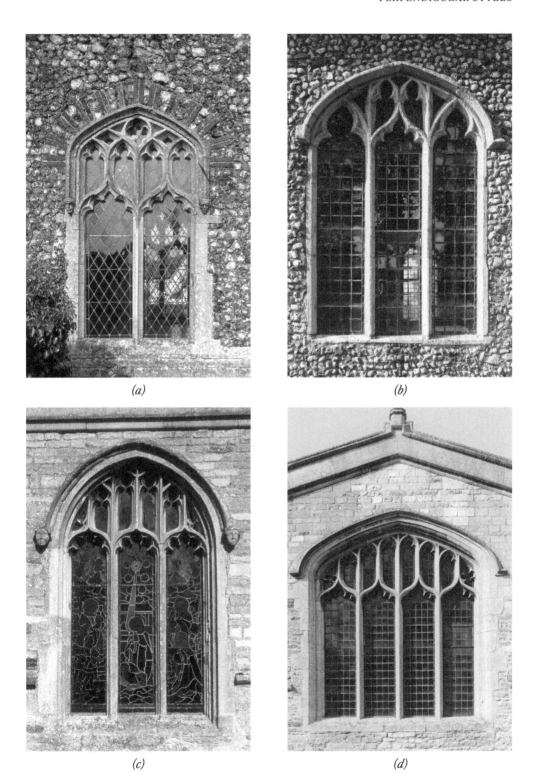

*(a)*        *(b)*

*(c)*        *(d)*

PLATE 62
*a. Badwell Ash   b. Hemblington   c. Hambleton   d. Gretton*

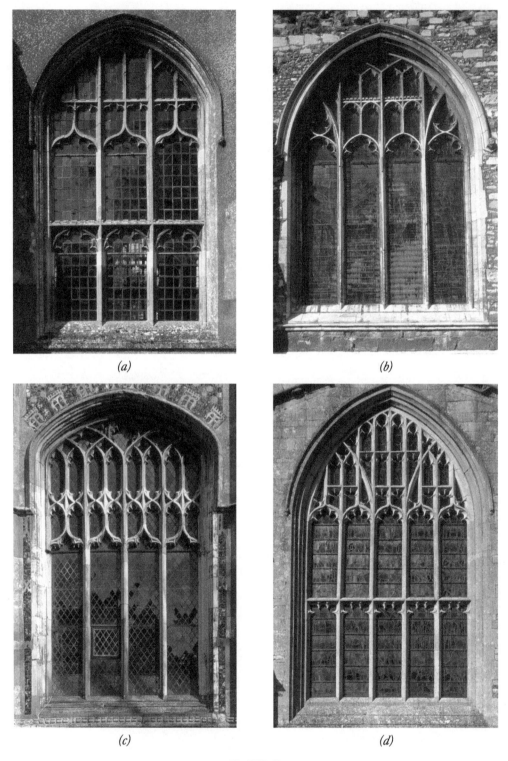

*(a)*  *(b)*

*(c)*  *(d)*

PLATE 63
*a. Walpole St Peter   b. St Neots   c. Bungay, St Mary   d. Langham*

as at Hambleton, Rutland *(Pl. 62c)*, or six in Drop tracery beneath a four-centred arch as at Lingwood, Norfolk. A taller middle light may have taller demi-panels, or panels of normal size supporting a small apex figure, or the sub-arch of the middle light itself may be higher with normal demi-panels.

Single bands of tracery also occur in larger windows. Four-light windows at Gretton *(Pl. 62d)* and Lowick, both with low four-centred arches, and one with a pointed arch and five lights at Langtoft, Lincs have only single bands of simple demi-panels, but generally in larger windows supertransoms subdivide the depth of the tracery into tiers.

## GRIDIRON TRACERY

The larger windows in which supertransoms subdivide the tracery horizontally are often described as having Gridiron tracery. Gridiron tracery is a more expansive version of supermullioned tracery used in larger windows that may or may not have subarcuations and intersections, and is composed of bands of demi-panels of more than one tier in height. The supermullions create a strong sense of verticality, forming a repetitive rectilinear pattern of demi-panels that to a greater or lesser extent may have horizontal subdivisions. The tracery of the supertransomed window at Langham *(Pl. 63d)*, that of the large east windows *(Pl. 64a)* and others at Grantham, and comparable patterns in many other large windows elsewhere are typical of this style. The term Gridiron is also used to describe large windows with several transoms below the tracery level.

## SUPERTRANSOMS

Whereas a transom is a horizontal member across a window below its springing level, a supertransom is one that crosses part or the full width of the window above springing level within the window tracery. It may be a foliated or battlemented moulding, or a latticed band. Being specific to Perpendicular windows (although supertransoms do occur, rarely, in Curvilinear windows) supertransoms introduce a marked note of horizontality into tracery that establishes a clear stylistic signature, though where they are not dominant features, they may be of minor importance relative to other aspects of a window's tracery style. Supertransoms are more common in windows with Supermullioned tracery than in those with Alternate, although short ones are sometimes seen in the hexagons of the latter.

Although not uncommon as a short bar in the middle compartment of three-light windows or across all three lights as at Walpole St Peter, Norfolk *(Pl. 63a)*, the structural purpose of a supertransom is to provide lateral stability to more extensive areas of tracery and it is therefore a characteristic feature of wider windows, though not necessarily for their full width, as in the four-light south aisle windows at St Neots, Cambs *(Pl. 63b)*.

At Southwold, Suffolk *(Col.Pl.XVIII)*, short horizontal bars subdivide hexagon figures within the Coincident subarcuations of the tower's four-light west window, and in a window of similar size at St Mary's, Bungay, Suffolk *(Pl.63c)* with a four-centred arch, two tiers of demi-panels in deep Drop tracery are separated by a latticed supertransom. There is a similar one but shorter between the two tiers of demi-panels in the central compartment of the Higham Ferrers window mentioned above *(Col.Pl.XV)*.

Five-light subarcuated windows with pointed arches at Grantham, Newark and Langham *(Pl.63d)* are typical of many others elsewhere and although having a similar visual structure, they incorporate different arrangements of supertransoms within their centre compartments and subarcuations. Larger windows show comparable variety of detail; at Grantham *(Pl.64a)*, the six-light chancel east window has crested supertransoms in its centre compartment, and alongside it, in the north chapel's seven-light window with intersecting subarcuations the supertransoms are battlemented. This window also incorporates a few pre-Perpendicular motifs in its subarcuations – quatrefoils in their apices and raindrop daggers in their outer lights.

## TRACERY WITH PRE-PERPENDICULAR MOTIFS

As in the seven-light Grantham window *(Pl.64a)* referred to above, the Perpendicular tracery of many others also incorporates pre-Perpendicular motifs. There are two likely reasons for this; firstly, in earlier windows of the style that date from the Decorated/Perpendicular overlap period, despite the ravages of the Black Death in 1348, natural conservatism would have ensured a continuation of accepted ideas and so Curvilinear motifs were still retained within the new designs, and secondly, after the new style had become established, reaction against its strict rectilinear functionalism prompted reintroduction of some of the old curved forms, in particular quatrefoils, reticulations, daggers, mouchettes and soufflets.

A three-light east window at Carlby *(Pl.64b)* is probably an instance of the earlier tendency. Its outer lights are Coincident and have the Late Geometric motif of the trilobe in their apices with trefoiled sub-arches below, while above the ogee middle light a supermullion and a short supertransom, both of the same thick section as the window mullions, introduce the Perpendicular element by dividing the apex space into four small compartments. By contrast, the quatrefoils and dagger motifs in the seven-light Grantham window are probably legacies of the later influence. Having in mind, though, that the Perpendicular style prevailed from the second half of the fourteenth century until well into the sixteenth, it is not usually possible to know which of these influences might have applied to particular windows.

At its simplest, the introduction of pre-Perpendicular motifs was the inclusion of a quatrefoil above the middle light of three-light windows of a

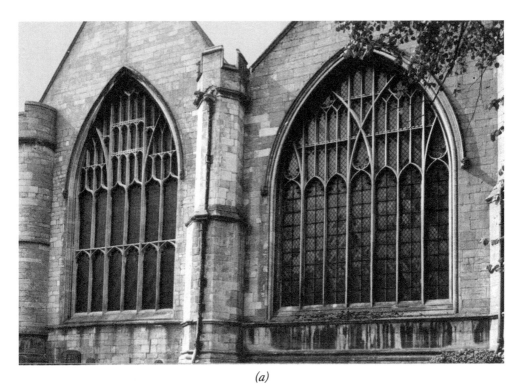

*(a)*

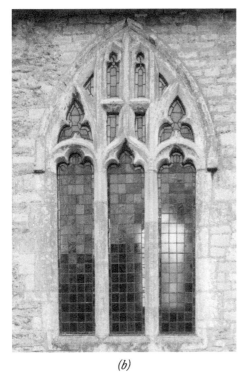

*(b)*

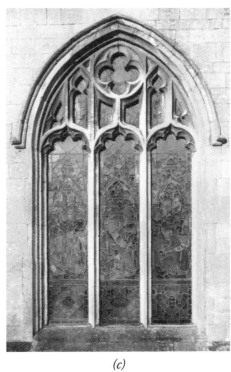

*(c)*

PLATE 64
*a. Grantham, east end   b. Carlby   c. Uffington*

129

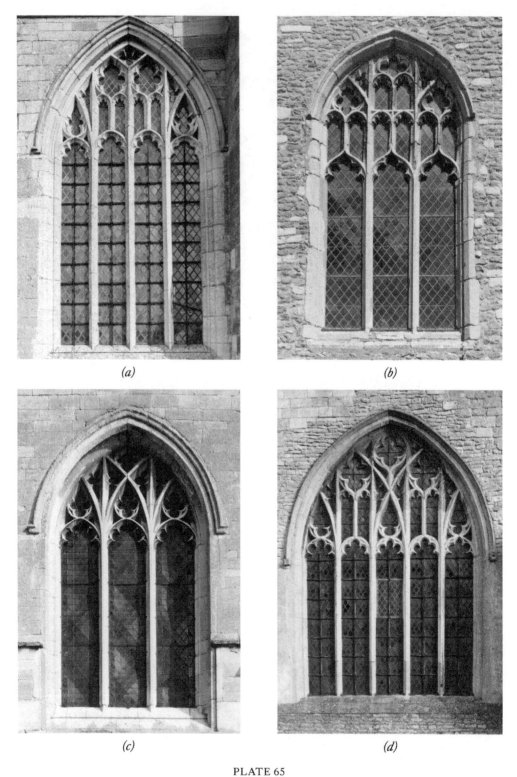

PLATE 65
*a. Fotheringhay   b. Swavesey   c. Lowick   d. Empingham*

design similar in principle to the Hambleton window *(Pl. 62c)*. Of this design, two almost identical windows at Uffington, Lincs *(Pl. 64c)* and Whissendine, Rutland are typical of many others elsewhere; they have the through mullion visual structure with three Non-Coincident lights of equal height. In an equally numerous development of this format, the side lights become taller and Coincident with the window arch, receiving Curvilinear tracery motifs in their apices. At Fotheringhay *(Pl. 65a)*, a four-light version of this format has twin centre compartments each with a soufflet at the top, and in a five-light window at Cowbit, Lincs *(Pl. 4a)* the one-light centre compartment serves to mark out two Coincident subarcuations whose apex vesical soufflets are the dominant motifs.

A variation of the format in a Coincident three-light window at Swavesey, Cambs *(Pl. 65b)* is unusual in having Drop tracery under a normal though rather obtuse pointed arch; its middle compartment, defined by through mullions as at Uffington, has two tiers of demi-panels surmounted by an apex quatrefoil, with side light tracery of a quatrefoil over demi-panels. The five-light east window at this church follows the same general pattern but without the quatrefoils in the side lights.

The association of Curvilinear motifs with a Perpendicular visual framework that consists of intersecting subarcuations and through mullions produces a distinctive appearance that could almost be regarded as a separate style insofar as it is the visual impact of this combination of framework elements rather than the tracery detail that creates the strongest impression. Comparable three-light windows at Lowick *(Pl. 65c)* and Raunds, the one of five lights at Empingham *(Pl. 65d)* and the seven-light Grantham window *(Pl. 64a)* are representative of this combination. The former two are remarkable in that, with Curvilinear tracery motifs, their through mullions are their only Perpendicular features.

Four Coincident sidelight tracery patterns predominate, derived from Curvilinear windows with Petal or Leaf-Stem tracery. A raindrop dagger over a pointed or segmental sub-arch as at Fotheringhay, Northants *(Pl. 65a)* is the most common. The others are: similar figures over two small convergent mouchettes that form an ogee sub-arch as in the lights at Frisby-on-the-Wreake *(Pl. 50a)* or Terrington St Clement *(frontispiece)*; foliated segments instead of mouchettes in a similar arrangement as at Attleborough *(Pl. 50c)*; and a trilobe as at Holbeach *(Pl. 50b)*. These patterns occur in the side lights of windows of all sizes and in the middle lights of many.

Coincident windows at Great Barton and Cavendish, both in Suffolk, represent another treatment for the tracery within the middle light without departing from the common format of the three-light windows described above. At the former there is simply a pair of tall demi-panels, and at the latter two supertransomed tiers each of four narrow panels are augmented by four

small quatrefoils. In its sidelight tracery, a pair of foliated segments support a quatrefoil instead of the usual raindrop dagger of this pattern.

There are, it need hardly be said, many distinctive tracery patterns that do not conform to specific categories but combine Curvilinear and Perpendicular elements in a variety of different ways. A four-light window at Whissendine *(Pl. 66a)* is representative of the satisfying aesthetic effect that can be attained when motifs of the two styles are skilfully blended. Under a well-proportioned four-centred arch, four equal lights each contain two demi-panels supporting a raindrop dagger; the lights form two Coincident subarcuations with a similar but inverted dagger in their apices, and merge fluently with a larger version of the same figure in the windowhead. The demi-panels are the only Perpendicular features of the composition.

## ANGULAR TRACERY

Shallow curvature and angularity of the kind seen in some supermullioned Alternate tracery like that at Harlton are the dominant characteristics of a few windows like those at Sporle, Norfolk, Aswarby, Lincs and St Nicholas, King's Lynn. In this unusual style, straight or nearly straight lines take the place of curves in the tracery details. The Sporle window *(Pl. 66b)* has a pointed arch with three lights; the outer ones are Coincident with the window arch and the inner curves of their arches are the only orthodox curves in the tracery; their sub-arches are formed from diagonally crossed members, only slightly curved, that give the heads of the lights an almost triangular shape, with an angular figure above and triangular spandrels. The head of the middle light matches the sub-arches of the outer lights and supports a short supertransom below a pair of demi-panels with inverted V-shape heads. The King's Lynn window is similar though it has a segmental arch with normal figures in the shoulder spandrels, and while the Aswarby window *(Pl. 66c)* has conventional sub-arches, its tracery has a close equivalance to the Sporle design.

## PANELLED TRACERY

This heading is used for the Perpendicular tracery type defined by Freeman as that in which the window lights extend at their full width up to the window arch, without subdivision or other tracery in their heads. It is one of those categories in which the visual framework is part of the style.

In larger windows, the lights may be subdivided horizontally by transoms within and across them. The west window at Fotheringhay *(Pl. 66d)*, with a transom at the arch's springing level, has eight lights, divided into two four-light Coincident subarcuations within which the lights are carried up only to the subarcuation arches; in the window's curved diamond apex the two centre lights reach the window arch flanked by foliated spandrel triangles.

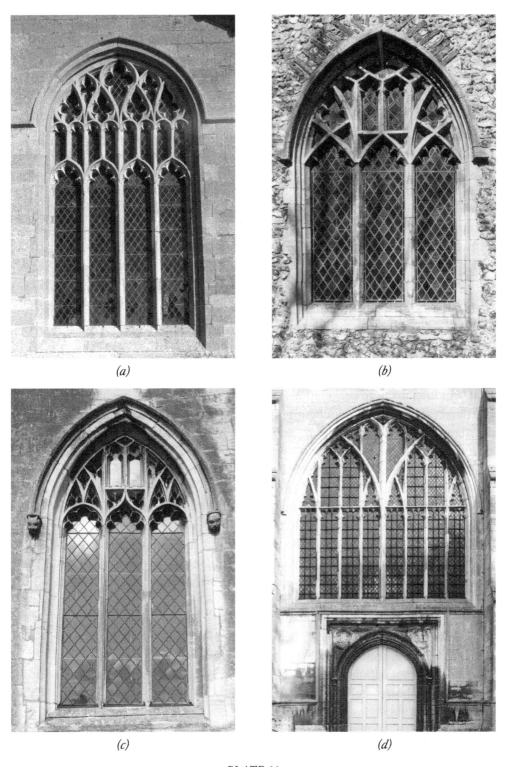

PLATE 66
*a. Whissendine   b. Sporle   c. Aswarby   d. Fotheringhay*

## LATER PERPENDICULAR

It was mainly during the second half of the fifteenth century and in the early sixteenth that a less emphatic interpretation of Perpendicular tracery emerged. In a significant departure from the norm, mullions in these windows were not continued through to the window arch, and thus one of the defining features of Perpendicular styles was to some extent abandoned. Most of the windows in which this trend was adopted have relatively low arches, either four-centred or segmental.

In two-light windows, like the four-centred ones at Badwell Ash *(Pl. 62a)*, Wortham *(Col. Pl. XVII)* and many others where the mullions do not extend to the window arch, a single band of demi-panel tracery establishes their Perpendicular style. However, some contemporary windows without tracery panels but otherwise similar have no specifically Perpendicular features; their mullion forks to produce a flattened form of Y-tracery, a pattern common beneath low, four-centred or segmental window arches where headroom below an eaves or parapet may be limited  The clerestory windows at Earl Stonham, Suffolk *(Pl. 67a)* are typical.

The analogy with the Y-tracery and Intersecting tracery of the early fourteenth century shows also in three-light windows. A four-centred three-light window in the tower at Elmswell and a similar one at Harringworth, Northants *(Pl. 67b)* have cinquefoil lights with foliations in the intersection apertures, but their tracery has no vertical members. So although actually of the Perpendicular period, they too have no specifically Perpendicular features.

A common four-light pattern beneath a four-centred arch has two Coincident subarcuations with a quatrefoil in the diamond-shaped apex. With thirteenth-century blind arcading below, the upper stage of the south aisle at All Saints, Stamford, Lincs, datable to the late fifteenth century, has a simple version with no tracery in the lights *(Pl. 67c)*, and the same basic pattern is followed in the south aisle of St Michael at Coslany, Norwich of the early sixteenth century, though the windows there are rather larger and with demi-panels and more elaboration in the lights.

Characteristic also of late Perpendicular tracery is the curious five-light east window at Castor *(Pl. 67d)* in which none of the mullions reach the four-centred window arch. Its lights are wider than normal and form two Coincident subarcuations and a middle compartment. Below springing level the window is horizontally divided into three by transoms resting on the big trefoil heads of the lights, and in the subarcuations the lights terminate with ogee trefoils. The mullions that form the middle compartment terminate with a semi-circular arch at the window apex, below which are two demi-panels with a small eyelet above. Large Curvilinear mouchettes fill the spandrels between the middle compartment and the subarcuations.

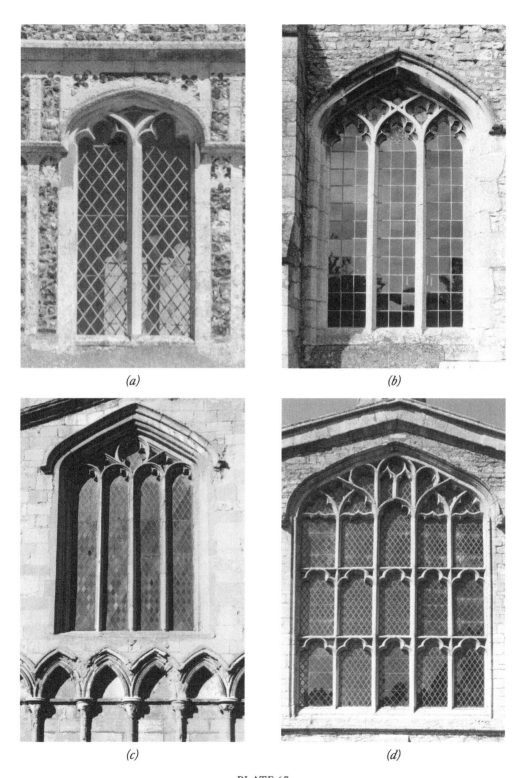

*(a)*        *(b)*

*(c)*        *(d)*

PLATE 67
*a. Earl Stonham   b. Harringworth   c. Stamford, All Saints   d. Castor*

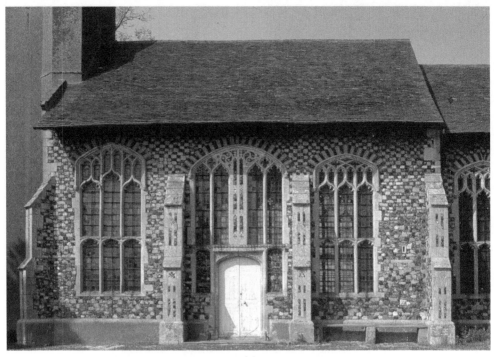

*(a)*

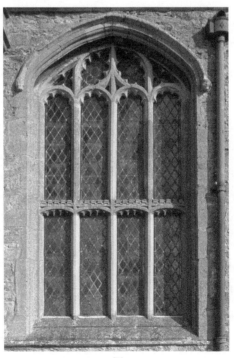

*(b)*

PLATE 68
*a. Gipping   b. Lowick*

At the little church of Gipping, Suffolk *(Pl.68a)* a conventional Perpendicular window is associated in the same wall with others that exhibit the Late tendency. Three-light windows at each end of the south wall, both with four-centred arches and a single band of demi-panel tracery above ogee lights, differ from each other in that the mullions of the western one run through to the window arch but in the other they form two-light subarcuations with flat intersection of the type adopted in the Harringworth window. The central feature in this wall is a composite window under a four-centred arch comprising a pair of individual two-light windows with pointed cinquefoiled lights and a quatrefoil in their apices, but with no Perpendicular features; between them a wide central mullion faced with flushwork panelling fans out in the window apex.

The centre mullion is the only one in a four-light south transept window at Lowick *(68b)* that extends to the four-centred window arch; the other two curve inwards at the top to form Curvilinear falchions above the two inner lights. This centre mullion and a battlemented transom above lower lights are the window's only definitive Perpendicular features.

Cinquefoiled arches to the lights below the transoms in this Lowick window and in the western one at Gipping are both segmental with a very shallow rise. This feature could be considered as signifying the culmination of development in England of medieval church window tracery; in due course, this late motif of the Perpendicular phase lost its foliations, and eventually the arch element of the lights disappeared, leaving just straight transoms between the mullions, to usher in the typical Tudor domestic gridiron window.

Finally, in an unprecedented departure from the rectilinear tradition of the Perpendicular style, the tracery of an idiosyncratic east window at Barsham, Suffolk *(Col.Pl.XIX)* makes a spectacular break with convention. Restored in 1906 after damage by lightning, the window has a pointed arch but instead of normal lights with tracery above, the mullions, though still straight, are aligned diagonally to create a unique lattice grid over the whole of the window; this pattern is then extended beyond the outlines of the window as flushwork, covering the rest of the wall. No certain date has been established for this extraordinary design but it has been interpreted as a rebus of the shield of Sir Edward Etchingham, the patron of the church in the sixteenth century. The pointed window shape mirrors that of a shield, inverted!

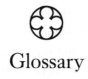

# Glossary

| | |
|---|---|
| Alternate | A Perpendicular tracery style based on supermullions rising from the apices of window lights to form hexagon shapes. |
| Arcade | A series of arches supported by columns or piers. |
| Archlet | A small arch of the same width as a window light, that springs from the apices of lights below or from those of lower archlets. |
| Arris | The sharp edge where two surfaces of masonry meet. |
| Ashlar | Squared freestone masonry. |
| Bar tracery | Moulded stone ribwork. |
| Bifoil | Any tracery figure with two lobes. Often elongated with tapered extremities. |
| Chamfer | The bevelled face produced by forming a splay in place of a right-angled arris on a member. |
| Cinquefoil | A tracery figure with five lobes. |
| Coincident | The condition when the curvature of the arch of a light or a subarcuation follows the curve of the arch that encloses it. |
| Colonnette | A small column or shaft. |
| Compartmentation | Vertical subdivision of a window into distinct separate parts. |
| Convergent | Inwards directional emphasis of tracery elements. |
| Crockets | Knob-like ornaments placed at regular intervals along the edges or angles of sloping features, e.g. spires or canopies. |
| Cruciform lobing | A four-petal pattern in which elements of soufflet or quatrefoil form to meet at a central point. |

| | |
|---|---|
| Cruciform quatrefoil | A quatrefoil with pointed lobes usually with vertical and horizontal orientation. |
| Curved diamond | A four-sided shape with concave sides and convex top curves commonly the resultant shape in the apex of Y-form windows and in the intersections within Intersecting tracery. |
| Curvilinear | Gothic architectural style of the first half of c.14 and later. |
| Cusp | The inward-pointing spur between adjacent lobes in tracery. |
| Dagger | A two-foiled tracery motif with unequal lobes. The smaller may be rounded or pointed, and the larger is tapered and pointed. |
| Demi-panel | A characteristic motif of Perpendicular tracery half the width of the window lights, defined by supermullions. |
| Divergent | Outwards directional emphasis of tracery elements. |
| Dogtooth | A moulding decoration of small contiguous pyramids, each one carved to form four leaf-like shapes. |
| Dressed stone | Fair face ashlar or stonework worked as mouldings. |
| Drop tracery | Window tracery below the level of the window arch springing. |
| Eyelet | A small piercing in the apex of a window or light. |
| Falchion | A generic term for ear-shaped and other irregular curved figures, usually foliated within, used in Curvilinear tracery. |
| Finial | The topmost terminal feature of a pinnacle, gable, etc. |
| Foil or foliation | A small tracery lobe terminating with cusps. It may be an incomplete circle or the shape of a pointed arch. |
| Geometric | Gothic architectural style of c.13 and early c.14. |
| Headstop | Termination of a hoodmould in the form of a head. |
| Hollow chamfer | A chamfer with a concave face to the bevelled plane. |
| Hoodmould | A projecting weather moulding above a window or door opening. |
| Jamb | The straight side of a doorway or window opening. |
| Knop | A swelled projection or terminal of e.g. a colonnette or finial. |
| Label | See Hoodmould. |
| Lancet | A slender single-light pointed window. |
| Light | An individual window opening. In windows with |

|  | multiple lights, distinct units are defined by the window mullions. |
|---|---|
| Lobe | A small tracery recess separated from others by cusps. |
| Mouchette | A curved variation of the dagger motif. |
| Mouchette subarcuation | A common two-light combination within a larger window in which the lights support a pair of divergent mouchettes on which rests an apex soufflet. |
| Mouchette wheel | Two or more interlocking curved mouchettes within a circle. |
| Mullion | A vertical member between the lights of a window. |
| Multifoil | A tracery figure with many internal lobes |
| Non-Coincident | The condition when the curvature of the arch of a light or subarcuation deviates from the arch that encloses it. |
| Oculus | See Eyelet |
| Ogee | Double curvature comprising concave and convex curves. |
| Orders | Of tracery, the relative gradations of tracery mouldings or foliations. |
| Panelled | Commonly used description of Perpendicular tracery patterns. |
| Pier | A masonry support for an arch or the arches of an arcade. |
| Plate tracery | Stone window headwork with piercings of simple shapes. |
| Quatrefoil | A figure with four lobes. |
| Raindrop dagger | A tracery figure with a rounded lower end tapering to a point at the top, with subordinate internal foliation. |
| Rebate | A rectangular recess along an edge, often to accommodate another component. |
| Roundel | A circular piercing or tracery figure. |
| Sinking | A carved recess in stonework that does not penetrate the stone. |
| Soufflet | A quatrefoil with rounded side lobes and pointed ones at top and bottom. A common variation has a rounded top lobe also. |
| Spandrel | In tracery, the residual spaces between the tracery motifs and the window arch, or between the motifs. |
| Spherical triangle | An equilateral triangle whose sides are arcs of circles radiused from the angles of the triangle. A Late Geometric motif. |

| | |
|---|---|
| Springing | The level at which the curve of an arch rises from its support. |
| Stiff-leaf capital | Stylised carved foliage capital typical of late c.13. |
| Strap tracery | Tracery formed with flat stone members rather than bars. |
| Sub-arch | The small internal arch at the base of any tracery within a light. |
| Subarcuation | A single light, or group of lights under a shared arch, within a larger arch. |
| Subordinate | Recessed relative to more dominant tracery elements. |
| Sunk-spandrel tracery | Tracery with unpierced sinkings. |
| Supermullion | A lesser mullion rising from the apex of a window light or a prolongation of a window mullion into the tracery area. |
| Supertransom | A horizontal member within a window's tracery that crosses part or the full width of the window. |
| Tracery | Patterns of stone ribwork in the upper part of Gothic windows. |
| Transom | A horizontal member of a window's structure below springing level. |
| Trefoil | A tracery figure with three, usually circular, lobes. |
| Trilobe | A trefoil with elongated pointed lobes. |
| Vesica | An upright almond-shaped tracery figure. |
| Vesical soufflet | A vesical shape containing a soufflet form as subordinate foliation. |

# Further Reading

Bond, F. *Gothic Architecture in England*. Batsford 1906.

Bony, J. *The English Decorated Style; Gothic Architecture Transformed 1250–1350*. Phaidon 1979.

Cocke, T. and others. *Recording a Church: An Illustrated Glossary*. Council for British Archaeology. 3rd Edn 1996.

Curl, J.S. *Dictionary of Architecture and Landscape Architecture*. Oxford University Press. 2nd Edn 2006.

Elvy, J. *Tracery 1150–1350 AD*. Cinderhill Books. 2001

Freeman, E.A. *An Essay on the Origin and Development of Window Tracery in England*. 1851.

Harvey, J. *The Perpendicular Style*. Batsford 1978.

Pevsner, N. and others. *The Buildings of England*. Relevant County Volumes. Penguin and Yale University Press.

Sharpe, E. *Decorated Windows: A Series of Illustrations of the Window Tracery of the Decorated Style of Ecclesiastical Architecture*. J. van Voorst. 1849.

# County Directory of Places Referred to

## CAMBRIDGESHIRE

Bainton
Barnack
Bassingbourne
Castor
Chesterton
Etton
Fordham
Harlton

Helpston
Little Shelford
Longthorpe
Maxey
Northborough
Over
St Neots
Soham

Spaldwick
Stibbington
Sutton
Swavesey
Trumpington
Ufford
Yaxley

## ESSEX

Lawford

## GLOUCESTERSHIRE

Gloucester

## HERTFORDSHIRE

Ashwell          Sandon          Waltham Cross

## KENT

| | | |
|---|---|---|
| Bearstead | Chartham | Sheldwich |
| Bobbing | Cliffe | Thurnham |
| Boughton Aluph | East Malling | Ulcombe |

## LEICESTERSHIRE

| | | |
|---|---|---|
| Asfordby | Gaddesby | Melton Mowbray |
| Ashby Folville | Hallaton | Misterton |
| Barkby | Hoby | Somerby |
| Burton Lazars | Kibworth | South Croxton |
| Coston | Kirby Bellars | Stoke Golding |
| Frisby on the Wreake | Market Harborough | Wanlip |

## LINCOLNSHIRE

| | | |
|---|---|---|
| Ancaster | Donnington | Horbling |
| Aswarby | Dowsby | Langtoft |
| Barton on Humber | Ewerby | Long Bennington |
| Billingborough | Fishtoft | Morton |
| Boothby Pagnell | Folkingham | Norton Disney |
| Boston | Gosberton | Quarrington |
| Burton Coggles | Grantham | Rippingale |
| Carlby | Greatford | Scotton |
| Carlton Scroop | Great Gonerby | Sleaford |
| Castle Bytham | Great Hale | Stamford |
| Caythorpe | Grasby | Swaton |
| Claypole | Heckington | Swinstead |
| Colsterworth | Heydour | Threekingham |
| Cowbit | Holbeach | Uffington |
| Deeping St James | Honington | |

## LONDON

| | |
|---|---|
| Old St Paul's | Westminster |

## NORFOLK

Acle
Ashwellthorpe
Attleborough
Aylmerton
Bedingham
Beeston
Beeston St Lawrence
Billingford
Binham
Brammerton
Brandiston
Burnham Overy
Carbrooke
Castle Rising
Elsing
Garboldisham
Gissing
Great Ryburgh
Great Walsingham

Harpley
Hellington
Hemblington
Hingham
Ingham
King's Lynn
Lingwood
Little Massingham
Little Walsingham
Merton
Necton
North Creake
North Elmham
Norton Subcourse
Norwich
Quidenham
Rockland St Peter
Snettisham
South Creake

South Wooton
Sporle
Sustead
Swanton Abbotts
Syderstone
Terrington St Clement
Trowse Newton
Trunch
Tunstead
Tuttington
Walcott
Walpole St Peter
West Harling
West Walton
Weybourne
Winfarthing
Woodton

## NORTHAMPTONSHIRE

Aldwinkle
Barnwell
Bozeat
Brigstock
Bruerne
Bulwick
Cotterstock
Crick
Deene
Earls Barton
Finedon
Fotheringhay

Geddington
Glapthorn
Grafton Underwood
Great Addington
Gretton
Hardingstone
Harleston
Harringworth
Higham Ferrers
Kislingbury
Lowick
Nassington

Oundle
Polebrook
Raunds
Ravensthorpe
Ringstead
Rothwell
Stanion
Sudborough
Tansor
Wakerley
Warmington
Woodnewton

## NOTTINGHAMSHIRE

Beckingham
Bingham
Car Colston
Cromwell

Harby
Hawton
Muston
Newark

North Leverton
Orston

## OXFORDSHIRE

Chipping Norton    Oxford

## RUTLAND

| | | |
|---|---|---|
| Ashwell | Great Casterton | Lyddington |
| Barrowden | Hambleton | Morcott |
| Clipsham | Ketton | North Luffenham |
| Empingham | Langham | Tinwell |
| Glaston | Little Casterton | Whissendine |

## SHROPSHIRE

Shifnal

## SOMERSET

Yeovil

## STAFFORDSHIRE

Penkridge

## SUFFOLK

| | | |
|---|---|---|
| Badwell Ash | Earl Stonham | Rickinghall Inferior |
| Barsham | Elmswell | Southwold |
| Blundeston | Felsham | Syleham |
| Bungay | Gipping | Walberswick |
| Cavendish | Great Barton | Wortham |

## SUSSEX

| | | |
|---|---|---|
| Brede | Icklesham | Winchelsea |
| Etchingham | Lynchmere | |

### WARWICKSHIRE
Salford Priors

### WILTSHIRE
Edington

### YORKSHIRE

| Bolton Abbey | Hedon | Howden |
|---|---|---|
| | Kirkham | |

# General Index

Owing to the frequency of occurrence in the text of certain terms such as *Coincidence*, *Non-Coincidence*, *Curvilinear*, *Ogee*, *Subarcuation*, *Sub-arch*, *Mullion*, *Mouchette*, *Soufflet* and *Vesica*, their index entries are generally limited to those that define them or illustrate the contexts of their use; hence many references to their applications in individual windows are not indexed.

Notations in italic type indicate black and white plate numbers. Those in roman numerals indicate colour plates.

Acle 97
Aldwinkle 63, 106, *32a*
Alternate tracery *see under* Tracery
styles
Alternate Supermullioned tracery
*see under* Tracery styles
Ancaster 111, *56b*
Arches 6-10, Fig.1
Basket 6, 7
Four-centred 6, 120, 127, 128, 132,
134, 137
Ogee 8, 10
Pointed, two-centred, equilateral 6,
7
Pointed, two-centred, acute 6, 7
Pointed, two-centred, obtuse 6, 7
Round-headed 4, 6
Segmental 6, 7, 40, 71, 86, 90, 120,
124, 132
Straight-headed 5, 86, 90, 120
Three-centred 6, 7

Tudor 6, 7
Architectural styles 1, 2
Anglo-Norman *see under* Norman
Decorated 1, 2, 8, 10, 71, 90, 120,
128
Early English 1, 2, 71
First Pointed 2
Gothic 1, 6, 8, 10, 38, 67, 106
Lancet 1, 2, 8, 10, 32-45, 124, 139
Middle Pointed 2
Norman 1, 2, 4, 32
Perpendicular 1, 2, 8, 10, 61, 74,
106, 120, 128
Rectilinear 1
Romanesque 6
Saxon 4
Transitional 1, 2, 32
Asfordby 90
Ashby Folville 86, 90, 95, *47b*, IX
Ashwell, Herts 122, *60b*
Ashwell, Rutland 6, 78, 87, *38c*

Ashwellthorpe 8
Aswarby 132, *66c*
Asymmetrical forms 17, 75, 81, 91, 95,
   106, 108, 110, 116, 122
Attleborough 63, 74, 100, 111, 131,
   *32d, 50c*
Aylmerton 97, *49d*

Badwell Ash 124, 134, *62a*
Bainton 38, *16d*
Barkby 67
Barnack 26, 50, 71, 86, *2a, 11d, 36a,*
   *42b*
Barnwell 64, 78, 87, *39c*
Barrowden 22, 49, *9d*
Barton on Humber 14, 18, 49, 53, 57,
   71, *6b, 23b, 28a, 28d, 36b*
Bar tracery *see under* Tracery
   techniques
Barsham 137, XIX
Bassingbourne 8, *3c*
Bearstead 78, *39b*
Beckingham 120
Bedingham 22, 50, *24c*
Beeston 90
Beeston St Lawrence 40, 120, *20b, 59d*
Bifoil 83, 90, 95, 101, 104, 108, 138
Billingborough 40, 61, 67, 68, 111,
   *19*a, *35d, 56a*
Billingford 72, *36d*
Bingham 67, *34b*
Binham 18
Black Death 128
Blundeston 40, 63, 120, *19c, 32b*
Bobbing 68, *35b*
Bolton Abbey 106, 110, *53d*
Bond. F 2
Boothby Pagnell 8, 90, 104, *44b, 52c*
Boston 101, *51d*
Boughton Aluph 14, 100, 119, *50d,*
   *59c*
Bozeat 63, 97, *49a*
Brammerton 97, 120
Brandiston 2, *1b*
Brede 108, *54c*

Brigstock 124
Bruerne 78
Bulwick 74, 122, *37c*
Bungay 128, *63c*
Burnham Overy 8, *3a*
Burton Coggles 40, 78, 111, *20a, 56c*
Burton Lazars 38, 106, 108, 110, *16c,*
   *53a*

Carbrooke 74
Car Colston 106, 108, 120, *55a*
Carlby 21, 53 128, *7c, 64b*
Carlton Scroop 57, 76, 78, 87, 119,
   *38b*
Castle Bytham 30, 40, 49, *12d, 19b,*
   *23a*
Castle Rising 38, *17b*
Castor 30, 46, 49, 134, *22b, 67d*
Cavendish 26, 131
Caythorpe 14, 26, 45, 49, 111, 122, *4b,*
   *11a, 21a*
Chartham 10, 68, *35a*, IV
Chesterton 32, *13a*
Chichele, Archbishop, school of 124,
   XV
Chipping Norton 67, 78, 100, 108,
   *54b*, VII
Circle 11, 14, 16, 35, 46, 49, 50, 53,
   61, 100
Claypole 86, 100, *42a*, VIII
Cliffe 68, 106
Clipsham 18, 29, 35, 86, 90, *6c, 43d*
Coincidence Fig.2a, 11-17, 22, 35, 40,
   45, 46, 49, 138
Colonnette tracery *see under* Tracery
   techniques
Colsterworth 119, *58b*
Concave square 84, 91
Convergent 91, 95, 97, 138
Coston 57, 67, 122, *30a, 60d*
Cotterstock 17, 95, 110, XIV
Cowbit 131, *4a*
Crick 10, *3d*
Cromwell 106, 108, 110, *53c*
Cruciform lobing 97, 100, 119, 122, 138

Cruciform quatrefoil 21, 50, 53, 111, 138

Curved diamond 12, 14, 21, 35, 50, 71, 74, 91, 97, 100, 101, 122, 132, 139

Curvilinear tracery *see under* Tracery styles

Dagger 67, 74, 83, 84, 108, 128, 131, 132, 139

Decorated *see under* Architectural styles

Deene 87

Deeping St James 108, 120, *55b*

Demi-panel 116, 119, 124, 127, 128, 131, 132, 134, 137, 139

Dissolution of the Monasteries 1

Divergent 91, 95, 97, 101, 104, 139

Donnington 120

Dowsby 21, *8b*

Drop tracery *see under* Tracery techniques

Earls Barton 90, 124, *61b*

Earl Stonham 134, *67a*

Early English *see under* Architectural styles

Early Geometric tracery *see under* Tracery styles

East Malling 40, *20d*

Edington 116, 119, *58a*

Edward I, King 8

Eleanor Cross 8, 78, 81, *40a*

Eleanor, Queen 8

Elmswell 134

Elsing 108, XIII

Empingham 16, 74, 131, *65d*

Etchingham 106, 111, *57a*

Etton 22, 40, 124, *9a, 19d*

Falchion 83, 91-7, 101, 108, 110, 111, 137, 139

Falchion tracery *see under* Tracery styles

Felsham 61, 83, *31a*

Finedon 8, 87, *43c*

Fishtoft 14, 53, *27c*

Five-petal flower *see under* Petal tracery

Flamboyant tracery *see under* Tracery styles

Flowing tracery *see under* Tracery styles

Folkingham 46, 95, *22c, 47c*

Fordham 63

Fotheringhay 131, 132, *65a, 66d*

Four-petal flower *see under* Petal tracery

Freeman, E.A. 2, Fig.2, 116, 124, 132

Frisby on the Wreake 100, 101, 104, 131, *50a, 52a*

Gaddesby 40, 53, 57, 61, 91, 101, 119, 124, *27a, 30c, 45d, 59b*

Garboldisham 72

Geddington 8

Geometric tracery *see under* Tracery styles

Gipping 137, *68a*

Gissing 4

Glapthorn 21, 22, 30, 57, 72, 81, *7d, 12b*

Glaston 95, 119, *47d, 59a*

Gloucester 116

Gosberton 67, *34a*

Grafton Underwood 22, 91, 100, *10d*

Grantham 14, 26, 49, 72, 74, 95, 104, 127, 128, 131, *4c, 23d, 48a, 64a*, V

Grasby 18, 21, *8a*

Great Addington 22, 35, *10a*

Great Barton 131

Great Casterton 32, *13c*

Greatford 21, 71, *8c*

Great Gonerby 72, *37a*

Great Hale 16, 45, 64, 83, 86, *4d, 21b, 21c, 33c*

Great Ryburgh 90, 108, *44d*

Great Walsingham 90, 100

Gretton 14, 127, *62d*

Gridiron *see under* Tracery styles

Hallaton 22, 75, 90, 91, 95, 110, *9b, 46b*

Hambleton 127, 131, *62c*

Harby 8

Hardingstone 8, 78, *40a*

Harlestone 8, 87, *3b*

Harlton 122, 132, *60c*

Harpley 68

Harringworth 134, 137, *67b*

Hawton 63, 106, 108, 110

Heckington 10, 17, 61, 63, 90, 95, 101, 108, 110, *5c, 31d, 46c, 48b*

Hedon 57, 61, *29c*

Hellington 68

Helpston 8, 86

Hemblington 72, 124, *36c, 62b*

Henry VIII, King 1

Hexagon 115, 116, 119, 120, 122, 124, 128

Heydour 57, 97, *29b, 49c*

Hierarchy of tracery 29-30

Higham Ferrers 61, 124, 128, XV

Hingham 63, 64, *32c*

Hoby 67

Holbeach 83, 97, 100, 101, 131, *48c, 50b, 51a*

Honington 22, 30, 46, *22a*

Horbling 4, 95, 110, *2b, 46a*

Howden 49, 53, 57, 67, 81, 106, 110, *28c, 41a, 41b*, II

Icklesham 50, 78, *24b*

Ingham 16, 104, 119, *52d*

Intersecting tracery *see under* Tracery styles

Intersection 10, 11, 12, 14, 17, 63, 74, 84-6, 111, 115, 127, 128, 131, 134, 137

Kentish tracery *see under* Tracery styles

Ketton 49

Kibworth 91, 101, *45a*

King's Lynn 132

Kirby Bellars 95, 106, 110, *55d*

Kirkham 68

Kislingbury 17, 61, 111, *31c, 57c*

Lancet *see under* Architectural styles

Langham 16, 90, 127, 128, *63d*

Langtoft 127

Late Geometric tracery *see under* Tracery styles

Late Perpendicular tracery *see under* Tracery styles

Lawford 111, XI

Leafed Stem tracery *see under* Tracery styles

Lingwood 127

Little Casterton 30, 35, 124, *15b, 15c, 61a*

Little Massingham 91

Little Shelford 74

Little Walsingham 53, I

London, Old St Paul's 116

London, Westminster 8, 18

Long Bennington 90

Longthorpe 30, 35, *14d*

Lowick 74, 127, 131, 137, *65c, 68b*

Lyddington 75, 110, 124

Lynchmere 21, *7a*

Market Harborough 53, 67

Maxey 122

Melton Mowbray 57, 61, 72, *30b*, VI

Merton 26, 74, 75, *11c, 37d*

Misterton 61, *30d*

Mixed tracery *see under* Tracery styles

Morcott 122

Morton 64, *33d*

Mouchette 83, 90, 91, 95, 97, 100, 101, 104, 106, 128, 134, 140

Mouchette Subarcuation 91, 95, 104, 140

Mouchette Wheel 61, 111, 140

Mullion 26, 29, 30-1, 38, 40, 71, 101, 106, 115, 116, 124, 134, 140

Muston 22, 76, 108, *9c*

Nassington 38, 87, *18a*

Necton 119, *58c*

Newark 63, 95, 128

Non-Coincidence Fig.2b, 11-17, 21, 22, 35, 46, 49, 140

Northborough 2, 8, 22, 53, 63, 67, *1a, 26d, 34d*, III

North Creake 50, *25b*
North Elmham 90, 120, *44a*
North Leverton 67, 106, *53b*
North Luffenham 61, 68
Norton Disney 22, 26, 35, 38, 50, 71, *10c*
Norton Subcourse 68, 87, 119, *43b*
Norwich 97, 134

Ogee curvature 8, 10, 22, 49, 71, 72, 76-83, 84, 110, 140
  as a window shape 7, 8, 10, 87
  in lights 8, 38, 40, 45, 61, 78-83, 87, 95, 97, 104, 106, 108, 119
  in subarcuations 8, 16, 63, 83, 84, 86, 95, 101, 110, 115
  in tracery figures 83, 87-90, 106, 115, 120
Ogee Intersecting tracery *see under* Tracery styles
Orders, of tracery 29, 30, 53, 71, 140
Orston 53, *26b, 26c*
Oundle 17, 38, 50, 53, 61, *18b, 24d, 26a, 31b*
Over 87
Oxford 108, *54d*

Panel tracery *see under* Tracery styles
Penkridge 95
Perpendicular *see under* Architectural styles and Tracery styles
Petal tracery *see under* Tracery styles
Pevsner. N 2, 71, 81
Plate tracery *see under* Tracery techniques
Polebrook 4, 38, *2c, 17a*
Proto-tracery 18

Quarrington 64, 67, 119, *33b*
Quidenham 57, 76, 87, *38a*

Raindrop 72, 84, 91, 128, 132, 140
Raunds 16, 30, 49, 74, 95, 119, 131, *12a, 46d*
Ravensthorpe 8

Reticulated tracery *see under* Tracery styles
Reticulation 67, 87-90, 91, 108, 111, 115, 116, 119, 120, 128
Rickinghall Inferior 50, *25d*
Rickman. T 1, 2
Ringstead 17, 75, 95, 110, *5d*
Rippingale 53, 111, *27d*
Rockland St Peter 30, 64, *12c*
Rothwell 64

St Neots 127, *63b*
Salford Priors 108, *54a*
Sandon 120, *60a*
Scotton 21, 22, 26, 35, *10b*
Segmental tracery *see under* Tracery styles
Sharpe. E 1, 2
Sheldwich 50, 87, *24a*
Shifnal 57, 67, 90, *28b, 34c, 44c*
Skeletal framework 10, 11-17
  *See also* Visual structure
Sleaford 10, 16, 26, 61, 63, 91, 95, 101, 108, 110, *5a, 5b, 51c*
Snettisham 16, 95, 97, 101, 104, 108, *47a, 52b*, XII
Soham 50, 63, 104, 108, 111, 120, *25a, 55c, 57b*
Somerby 74, 81, 91, 101, 106, *40c, 45b*
Soufflet 83, 91, 95, 97, 100, 101, 104, 128, 140, 141
South Creake 8, 86, *42d*
South Croxton 72
Southwold 128, XVIII
South Wooton 101, *51b*
Spaldwick 50, 53, *27b*
Spherical Square *see under* Tracery styles
Spherical Triangle *see under* Tracery styles
Sporle 132, *66b*
Stamford 134, *67c*
Stanion 26, 35, 49, 64, 72, 78, 81, *14a, 14b, 23c, 39a*

Stepped Archlet *see under* Tracery
styles
Stibbington 18, 111, *6a, 56d*
Stoke Golding 50, 68, 72, 81, *25c, 37b,*
*40b*
Strap tracery *see under* Tracery
techniques
Sub-arch 8, 12, 29, 40, 81, 83, 84, 131,
132, 141
Subarcuation 8, 10, 11-17, 29, 30, 49,
141
Sudborough 29, 35, 64, *14c, 33a*
Sunk-spandrel tracery *see under* Tracery
styles
Supermullion 116, 120, 122, 124, 127,
128, 141
Supermullioned tracery *see under*
Tracery styles
Supertransom 127, 128, 131, 132, 141
Sustead 91, *45c*
Sutton 97, 100, 104, 111, *49b, 57d*
Swanton Abbotts 119
Swaton 26, 32, 46, 87, *11b, 13b*, X
Swavesey 131, *65b*
Swinstead 8
Syderstone 83, *41d*
Syleham 32

Tansor 21, 30, 40, *6d, 20c*
Terrington St Clement 10, 16, 131,
frontispiece
Threekingham 4, 35, 50, 86, *16a, 42c*
Through Mullion *see under* Tracery
styles
Thurnham 14, 100
Tinwell 38, 124, *17c, 61c*
Tracery Styles 10, 11
    Curvilinear 1, 2, 10, 14, 16, 76-114,
        119, 120 , 128, 131, 132, 139
    Falchion 83, 91-7, 101, 139
    Flamboyant 2, 90, 104-10, 120
    Flowing 2
    Leafed Stem 101-4, 111, 131
    Ogee Intersecting 84-6, 110
    Petal 63, 97-100, 104, 111, 131

Reticulated 16, 57, 67, 87-90
Geometric 1, 2, 10, 14, 46, 57, 71,
    76, 78, 81, 84, 100, 139
    Early 2, 14, 46-9, 50, 53, 57, 64,
        72, 76
    Late 2, 14, 16, 35, 38, 49-75, 76,
        78, 111, 128
        Intersecting 16, 30, 35, 71-5, 134
        Kentish 68, 119
        Spherical Square 64, 68
        Spherical Triangle 30, Fig.3,
            63-4, 68, 78, 140
        Stepped Archlets 67, 138
        Unencircled foliated figures 50-7
        Vesical 17, 57-63, 141
        Y-tracery 30, 35, 71-2, 86, 134
Mixed 84, 111, 128-32
Perpendicular 31, 45, 72, 74, 84,
    106, 108, 114, 115-37
    Alternate 116, 119, 120, 122, 124,
        127, 138
    Alternate Supermullioned 120-2,
        132
    Gridiron 116, 127, 137
    Late 134-7
    Panel 116, 124, 132, 140
    Supermullioned 116, 124, 127
    Through Mullioned 115, 122-4,
        131
Unclassified 111
Tracery Techniques 18
    Bar 18, 22, 26, 30, 31, 35 , 40, 46,
        57, 138
    Colonnette 26, 138
    Drop 29, 67, 124, 131, 139
    Plate 21, 22, 57, 140
    Sculptural 26-9
    Strap 26, 29, 111, 141
    Sunk-spandrel 21-2, 30, 35, 38, 46,
        49, 71, 141
Transom 114, 124, 127, 132, 137, 141
Trilobe 16, 49, 50-7, 78, 81, 83, 100,
    141
Trowse Newton 50, 57, *29a*
Trumpington 74

Trunch 119
Tunstead 90, 100
Tuttington 119

Uffington 131, *64c*
Ufford 35, 50, 64, 74, 75, 81, 87, 110,
  *16b*, *43a*
Ulcombe 68, 83, *41c*
Unclassified tracery *see under* Tracery
  styles
Unencircled foliated figures 35, 38,
  50-7, 74, 91

Vesica 21, 22, 57-63, 76, 78, 83, 84,
  87
Visual structure 11, 12, 16, 17, 29, 61,
  74, 83, 87, 100, 115, 128
  *See also* Skeletal framework

Wakerley 16, 124, *61d*

Walberswick 124, XVI
Walcott 97, 119
Walpole St Peter 127, *63a*
Waltham Cross 8, 78
Wanlip 119
Warmington 31, 38, *18c*, *18d*
West Harling 21, *7b*
West Walton 22, 31, 46, *22d*
Weybourne 120
Whissendine 131, 132, *66a*
Winchelsea 68, *35c*
Winfarthing 78, *39d*
Woodnewton 35, *15a*
Woodton 97, 120
Wortham 124, 134, XVII

Yaxley 10, 38, 50, 57, 90, *17d*
Yeovil 119, *58d*
Y-form 8, 12, 35, 78
Y-tracery *see under* Tracery styles